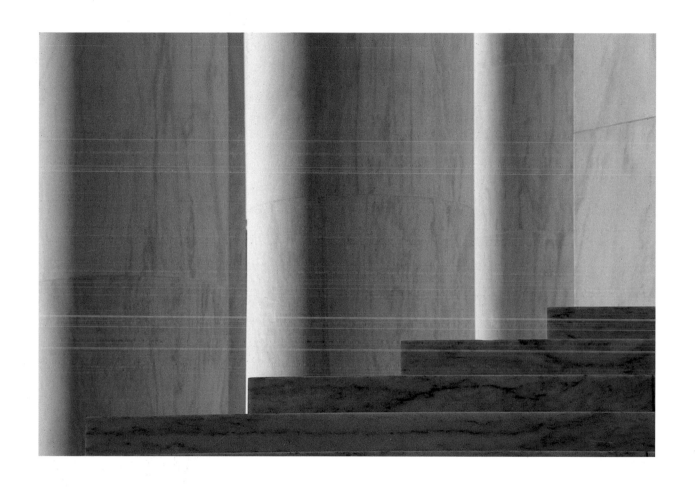

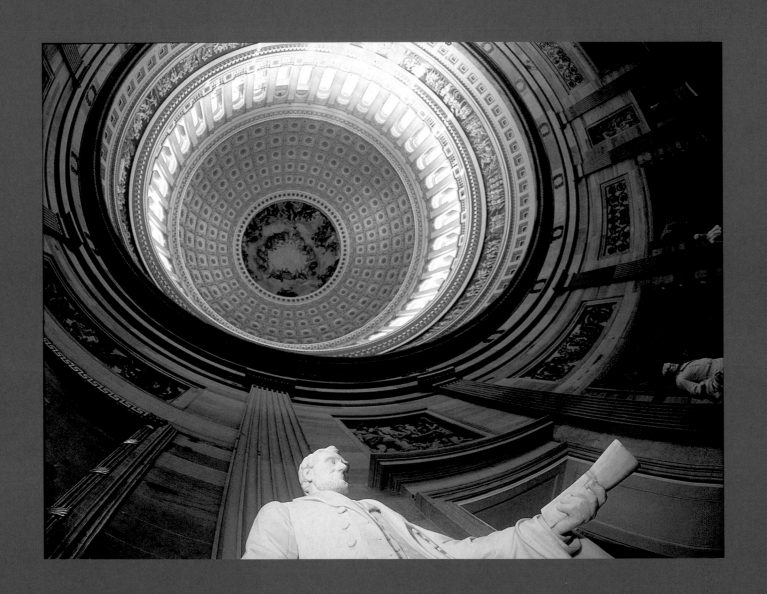

WASHINGTON

★ ★ ★

PORTRAIT OF A CITY

Revised Edition

PHOTOGRAPHS & TEXT BY STEVE GOTTLIEB

TAYLOR TRADE PUBLISHING

Lanham/New York/Boulder/Toronto/Plymouth,UK

Published by Taylor Trade Publishing
An imprint of The Rowman & Littlefield Publishing Group, Inc.
4501 Forbes Boulevard, Suite 200, Lanham, Maryland 20706
http://www.rlpgtrade.com

Estover Road, Plymouth PL6 7PY, United Kingdom

Distributed by National Book Network

Book Design: Steve Gottlieb
Fine art prints and stock usage of images in this book are available.
Contact steve@gottliebphoto.com. D.C. Photo workshops contact
info@horizonworkshops.com

British Library Cataloguing in Publication Information Available

Library of Congress Cataloging-in-Publication Data

Gottlieb, Steven, 1946–
 Washington : portrait of a city / photographs and text by Steve Gottlieb. —
Rev. ed.
 p. cm.
 ISBN 978-1-58979-574-7 (pbk. : alk. paper)
 1. Washington (D.C.)—Pictorial works. 2. Seasons—Washington (D.C.)—
Pictorial works. I. Title.
F195.G66 2011
975.3'0420222—dc22

 2010025876

∞™ The paper used in this publication meets the minimum requirements of
American National Standard for Information Sciences—Permanence of Paper for
Printed Library Materials, ANSI/NISO Z39.48-1992.

Printed in Canada

INTRODUCTION

Falling in love . . . the true story of a long weekend.

Her name was Anna. We met right after graduating law school at the New York State Bar Exam preparatory course. She had sultry Mediterranean looks, a buoyant laugh and a smile wider than Julia Roberts'. Exhibiting restraint, I waited until completing both the course and the bar exam before pursuing her, which I did ardently. That summer we began to see each other often.

Before starting our first post-graduation jobs—we'd both accepted positions as associates in large Wall Street law firms—Anna and I decided to take our budding relationship to the next level . . . a long weekend out of town. Our trysting destination: Washington, D.C., a place neither of us had visited since grade school. Three days, alone together, to nurture our developing passion. As I packed my suitcase, I tingled with anticipation.

Alas, the emotional highlight of our trip was the packing that preceded it. For reasons inappropriate to air in a book of this nature, seventy-two hours together proved to be far more than our fledgling romance could withstand. And so, sad to say, Washington was the end of Anna. But every cloud, as the old saying goes, has a silver lining. In those three days I did fall in love—not with Anna, but with the city of Washington. Our nation's capital was irresistible. Stirring monuments, beautiful museums around a grand mall, venerable government edifices, a wide river and intimate canal, a rustic city park and broad diagonal boulevards.

Washington was so irresistible that after logging just one year at my first job, I said goodbye Wall Street, hello Pennsylvania Avenue.

My plane landed at Reagan National Airport on New Year's Day, 1974, amid a heavy snowstorm, adding drama to this transitional moment. A few days later I sat comfortably behind an oversized desk in the Old Executive Office Building. My office was so close to the White House that I could have sailed a paper plane from my fourth floor window onto the roof of the West Wing. My new business card proclaimed: Steve Gottlieb, Assistant General Counsel, Office of Management and Budget, Washington, D.C., and next to it was an embossed "Executive Office of the President" logo. Two miles from my office I had taken an apartment on Massachusetts Avenue, a few blocks from the Capitol dome.

I was now, officially and enthusiastically, a Washingtonian.

OMB was the first of several legal positions that occupied most of the next decade. During those "legal years," much of my spare time was spent nurturing my hobby of photography. My favorite subject was the city itself. In 1984, ten years after I'd first arrived, I showed my "amateur" pictures to a publisher; to my surprise and delight, he decided on the spot to publish them in a book. *Washington: Portrait of a City*, the precursor to this volume, was born. Many pictures from that book reappear between these covers.

My passion for photography far exceeded my passion for legal work, to put it mildly, so I decided to use *Portrait of a*

City as a springboard for a drastic career change. On the very day the book was published I handed an inscribed copy of my book to the Chairman of the Board of the corporation where I worked and resigned my job. I declared myself to be a photographer. I've never worked a single day as a lawyer since.

Because of this experience, I considered Washington more than my home, more than my favorite city, more even than the subject of my book. It actually was a central character, a veritable co-conspirator, in my career transformation.

After I became a professional photographer, Washington continued to provide favorite subject matter . . . the landmarks of the nation's capital, of course, but other aspects of the city as well, for Washington is, like other cities, filled with people and sculpture, parks and airports, flowers and neighborhoods. In the course of my career, which has included two books about America, I have photographed nearly every major city from coast to coast, but none have come even close to inspiring my photographic impulses like Washington.

My passion for Washington subjects is hardly unusual, to say the least. Washington's first prominent photographer was Mathew Brady, who most famously photographed President Lincoln and the Civil War battlefields that lie close to the nation's capital. Since that time a century and a half ago, professionals and amateurs alike have trained their cameras on the city. More film has been shot here, I feel certain, than in any other city in the world. My own contribution, made over a twenty-five year period, is in the neighborhood of thirty thousand pictures. Like Claude Monet with his lily pads and haystacks, I view the city over and over, again and again, interpreting it under different light, new seasons, changed perspectives, altered juxtapositions.

To bring a fresh eye to this photographically familiar place is a creative challenge . . . and a great joy . . . a joy that is enhanced by sharing with others my vision of this city, a city I have loved ever since that first long weekend many years ago.

★ ★ ★

Since writing these words for the 2004 hardcover edition, both the city and I have changed. I now spend more of my time teaching others to take pictures than taking them myself. The city has added an Indian Museum and a WWII Memorial, restored its Botanic Gardens, and built an abundance of new office buildings. But mostly the city and I have remained the same. I still feel the same thrill when turning my camera on this extraordinary place. And the city of six years ago—even the city of a quarter century ago when I first lived here—still looks fundamentally the same. To the extent the city has changed, I think it looks even better than before.

As you turn these pages, I hope you enjoy seeing the city through my eyes. It would please me if these images give you a fresh perspective on familiar subjects . . . and the impetus to get acquainted with places you may have missed.

Steve Gottlieb

THE MALL & MONUMENTS

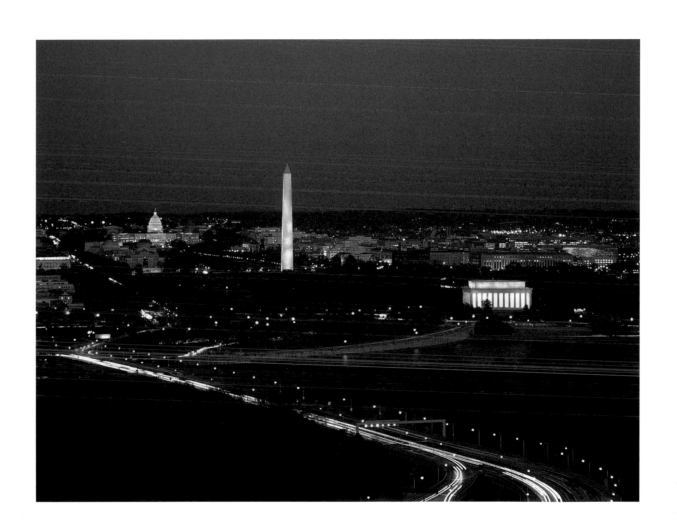

The "Mall and Monuments" is the familiar Washington, the Washington visitors always see. Two sweeping overviews help give us our bearings: a nighttime shot from a building rooftop in Rosslyn, Virginia (9), and a daytime vista from a helicopter (11). (Not that long ago you could fly above the city with few restrictions.)

Zooming closer in, two images that seem to be from another place and time: a series of rooftops on both north and south sides of the Mall (12) (taken from my old office in the Forrestal building); and the view I often saw leaving work in the winter: a silhouette of two Smithsonian buildings (13).

My favorite building on the Mall to photograph is contemporary—the East Building of the National Gallery, designed by famed architect, I. M. Pei. One viewpoint is through the blinds of the Gallery's West Building; the second is a detail of the marble façade, as seen through a camera turned 45 degrees off axis (14,15).

People by the millions pour inside the grand museums on the Mall to view and experience all manner of historic and cultural treasures, from the Mercury Space Capsule, Wright Brothers' Plane and Lindbergh's Spirit of St. Louis in the Air & Space Museum (16), to the stovepipe hat Lincoln wore the day he died, on display at the American History Museum (17).

The newest museum on the Mall is dedicated to the American Indian, with its rustic undulating sandstone exterior (18). Contrasting that museum with the National Gallery and the Museum of African Art (19), as well as their many museum neighbors, reveals one of the aesthetic wonders of the Mall: widely diverse architectural styles that resonate harmoniously together.

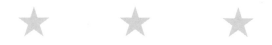

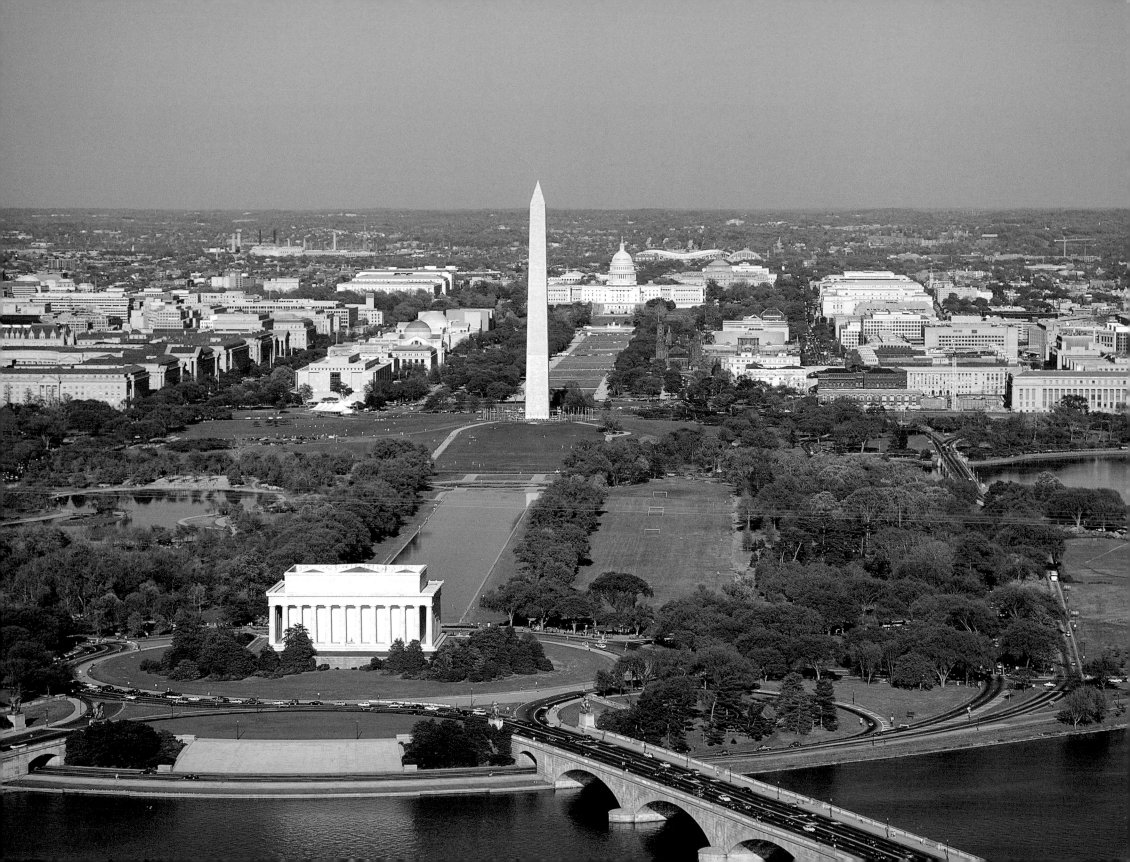

12 Rooftops on the Mall [preceding page: Mall Aerial]

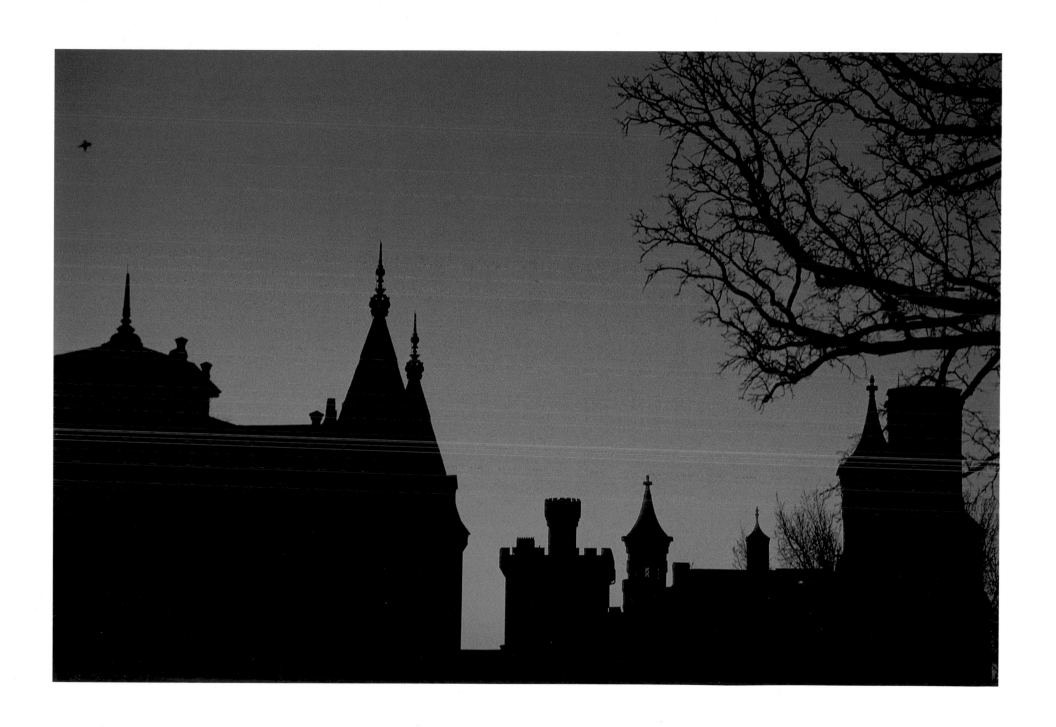

13 Smithsonian at Dusk

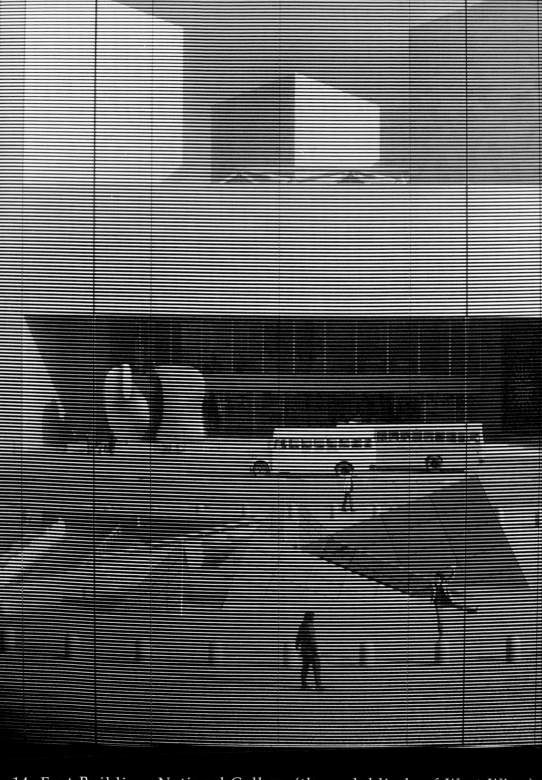

14 East Building, National Gallery (through blinds of West Wing)

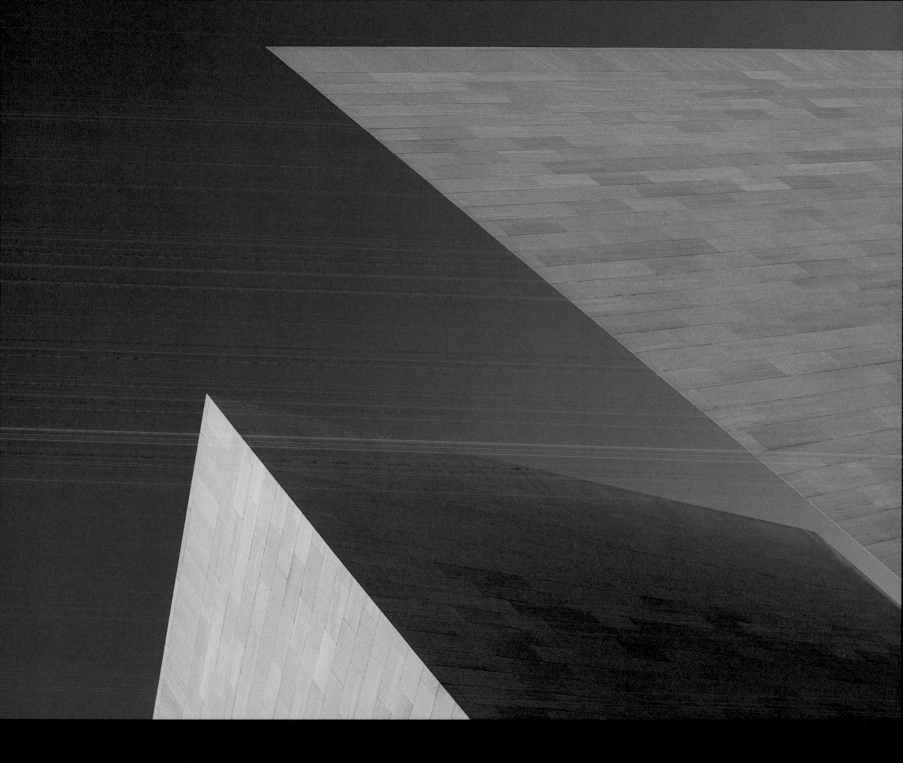

15 East Building, National Gallery of Art

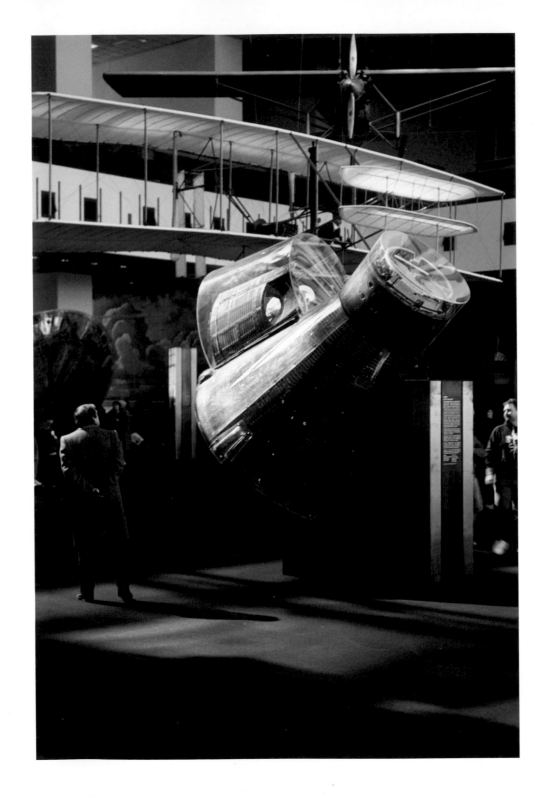

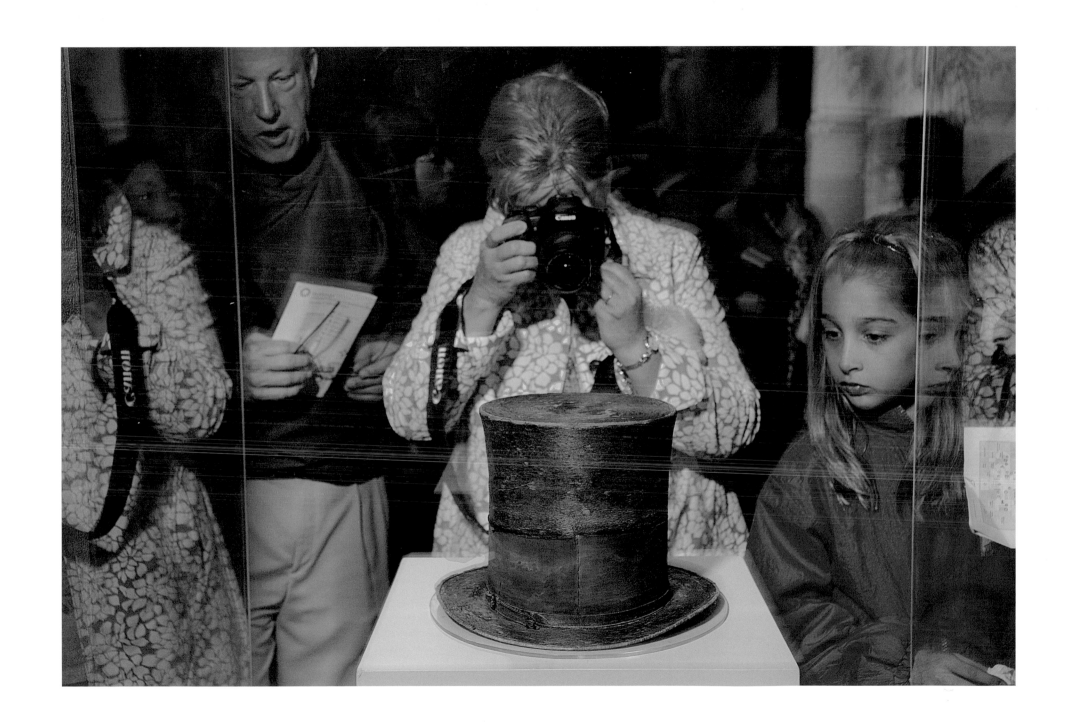

17 National Museum of American History (Lincoln's Hat)

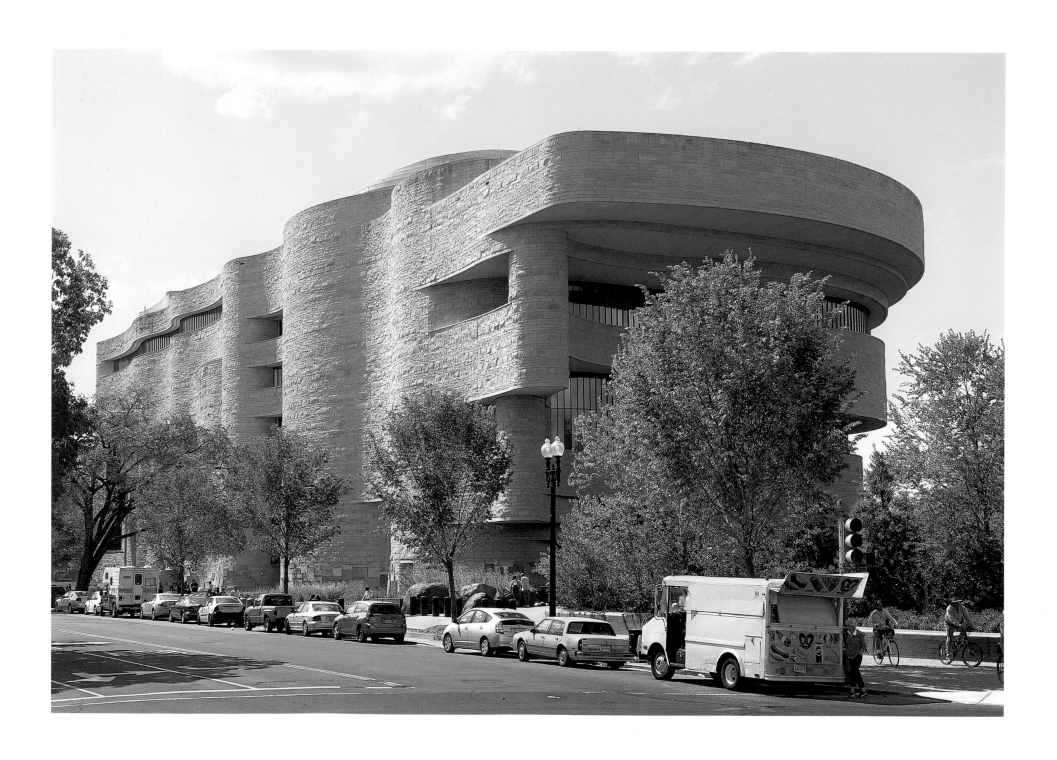

18 National Museum of the American Indian

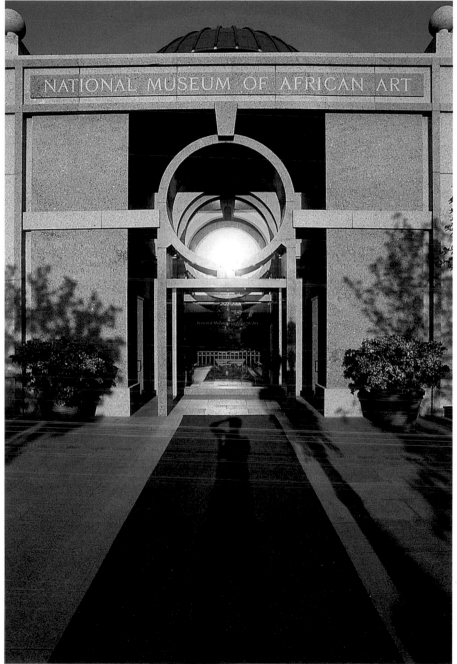

19 National Gallery; National Museum of African Art

The Mall provides a wide stretch of grass and pathways for people to walk, jog, picnic, cuddle, lollygag, toss a Frisbee, even ride a carousel (21). Under certain atmospheric conditions, the Mall magically alters its complexion, as in the Old Post Office rising out of an early morning mist (22) . . . or a couple slipping under the Mall's trees on a rainy autumn afternoon (23) . . . or a young lady kicking up snow beside the Lincoln Reflecting Pool (24,25).

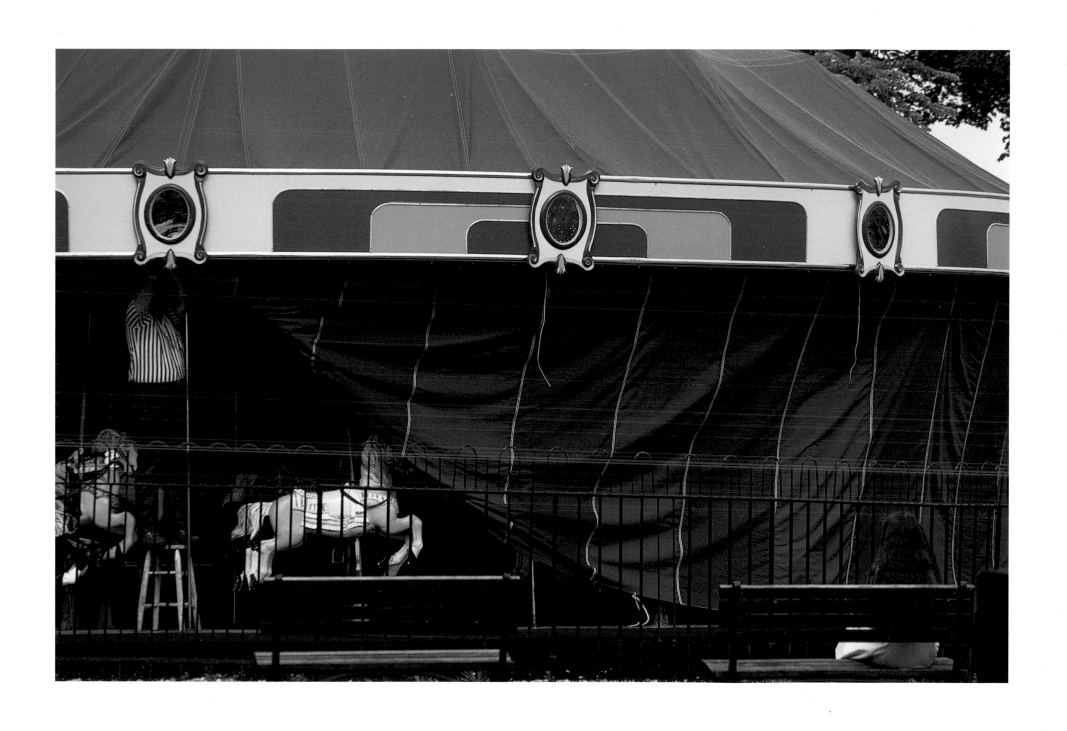

21 Mall Carousel [22 & 23 Old Post Office and Mall Trees Looking West; 24 & 25 Lincoln Reflecting Pool]

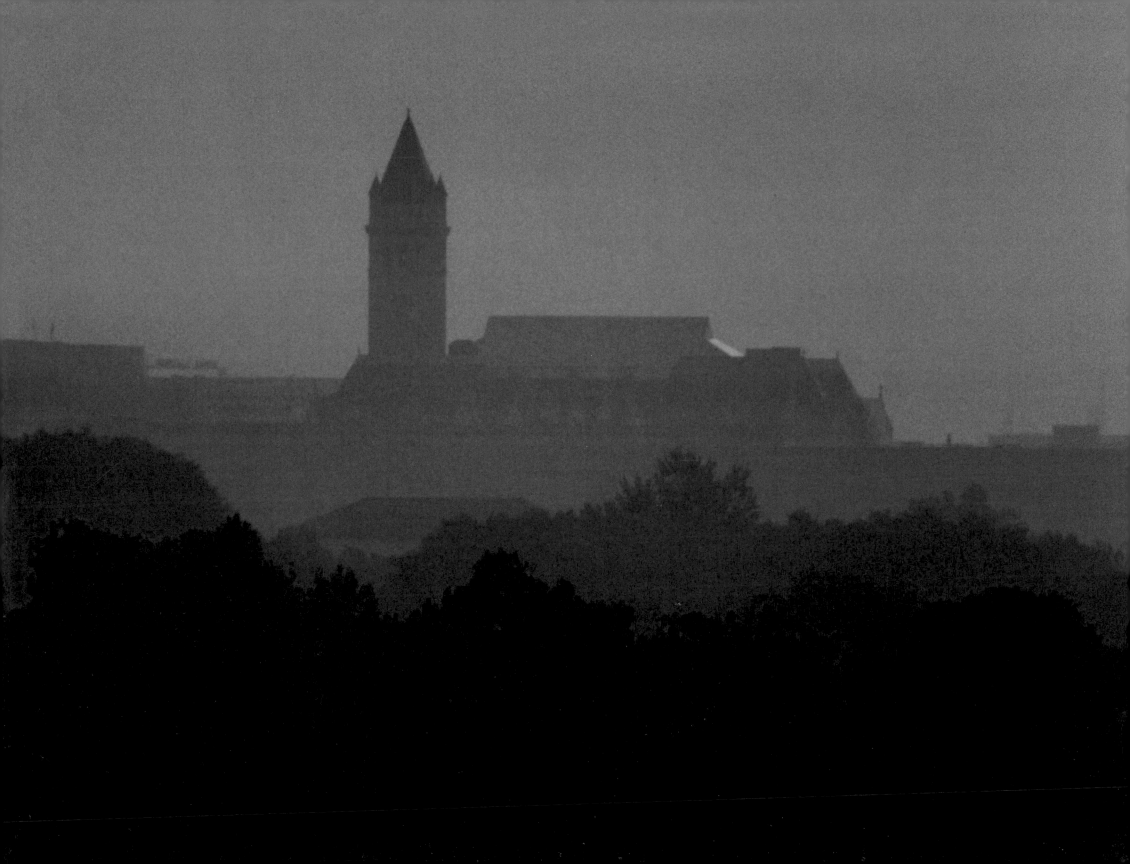

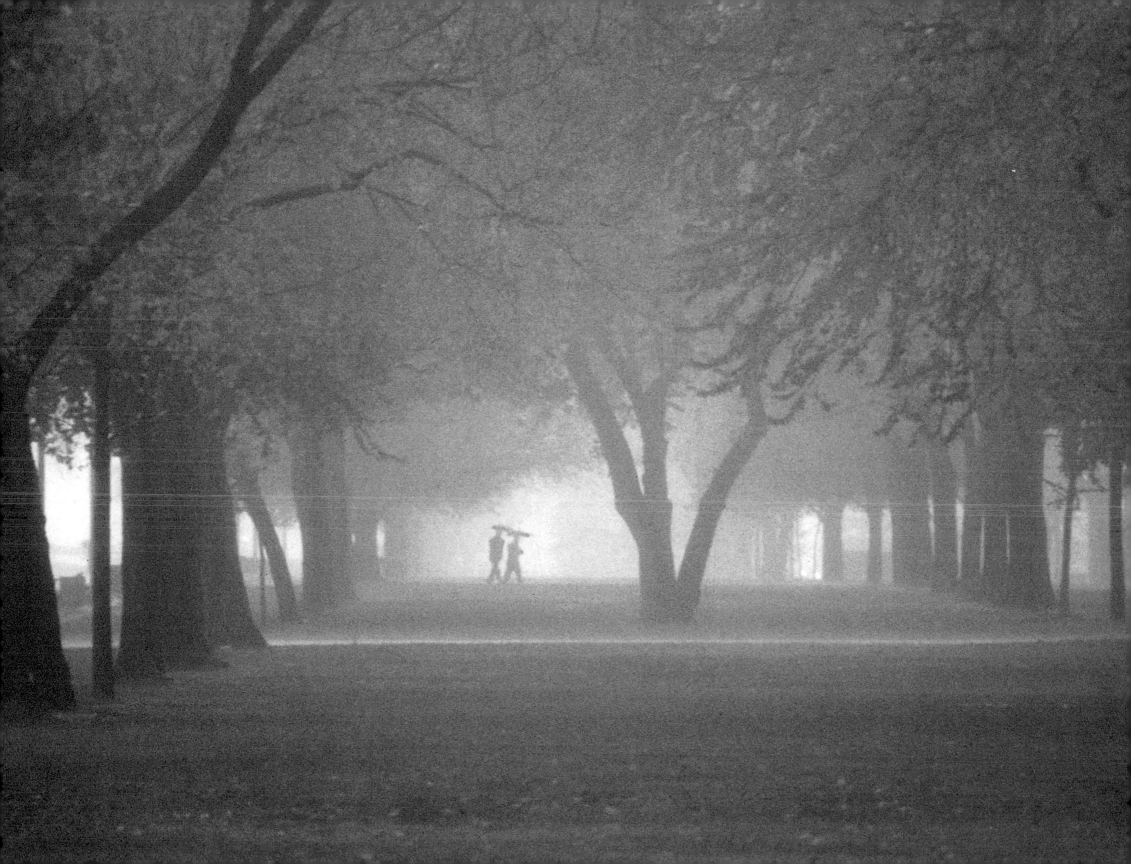

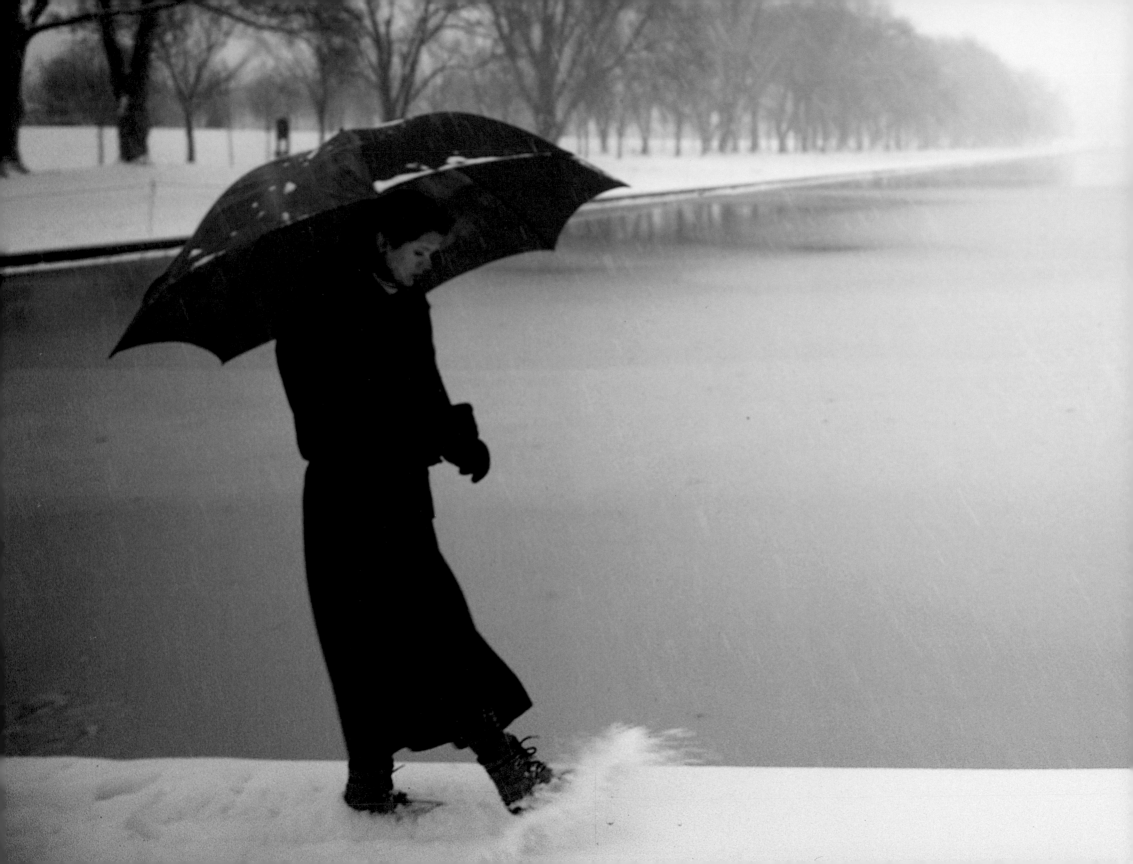

The big three memorials—Lincoln, Jefferson and Washington—are endlessly fascinating to this photographer. (As to why Washington is called a "monument" and the other two "memorials" I haven't a clue.) Shortly before sunrise, the streetlights on Memorial Bridge draw the eye to the west façade of the Lincoln Memorial (27). Shortly after sunrise—precisely on the first days of spring and fall—the sun comes up directly behind the Capitol dome and shines on the east façade and directly onto Daniel Chester French's famous sculpture (28). Art critic Frank Getlein observed that the reflection off the water running down the memorial's marble and granite steps (29) made him think of the blood of assassination—not just Lincoln's, but also that of Julius Caesar, whose wife dreamt the night before that she saw her husband's blood running down the steps of the Roman Capitol.

The Jefferson Memorial is an exquisite example of classical architecture, but the bronze statue inside is so dark it's difficult to decipher (30). At dusk, there's an ideal vantage point for capturing the Memorial bathed in varied colors of light from different sources, but that spot eluded me for years because it required the camera to be ten feet off the ground in the middle of the highly trafficked road that wraps around the Memorial's east side. Opportunity struck when the Washington Redskins made a rare appearance in the Super Bowl. With everyone watching the game, I climbed atop a ladder in the middle of that otherwise busy roadway . . . neither a car nor cop in sight (31). The Tidal Basin provides a wonderful reflective surface at sunrise (32). For monuments to endure, they need periodic, loving repairs (33).

The city fathers wisely decided to limit the height of all city buildings so the Washington Monument would retain its visual prominence (34,35). The absence of skyscrapers make everything in the city feel open and airy, on a more human scale . . . and very photographer-friendly. I'm not a flag-waving brand of patriot, but when a breeze lifts the flags that ring the monument, my hairs stand up (36,37).

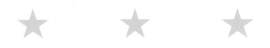

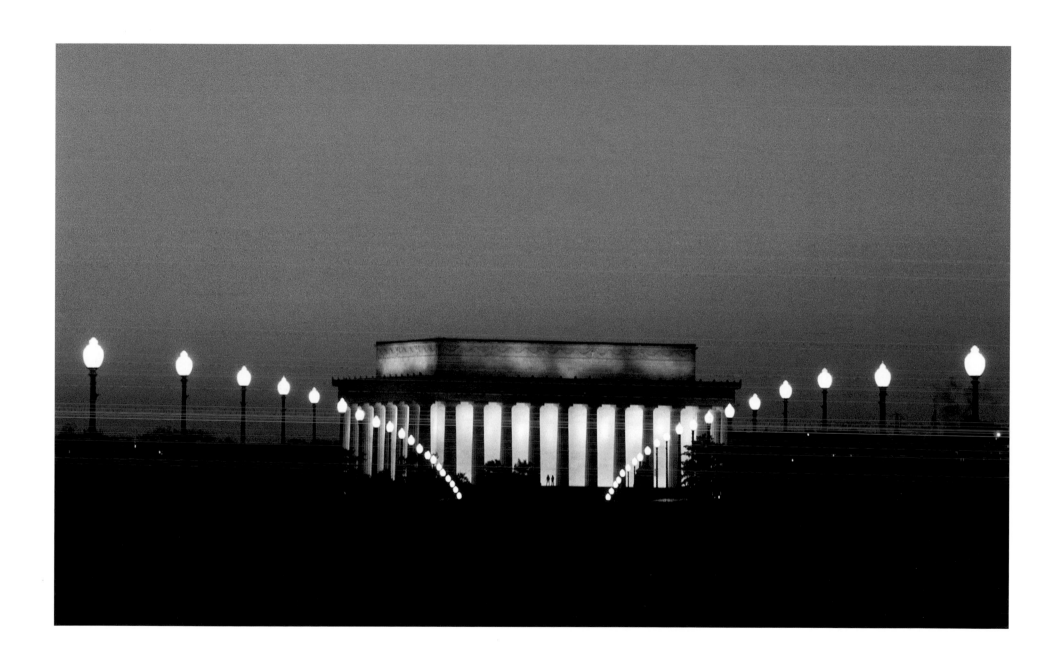

27 Lincoln Memorial at Sunrise

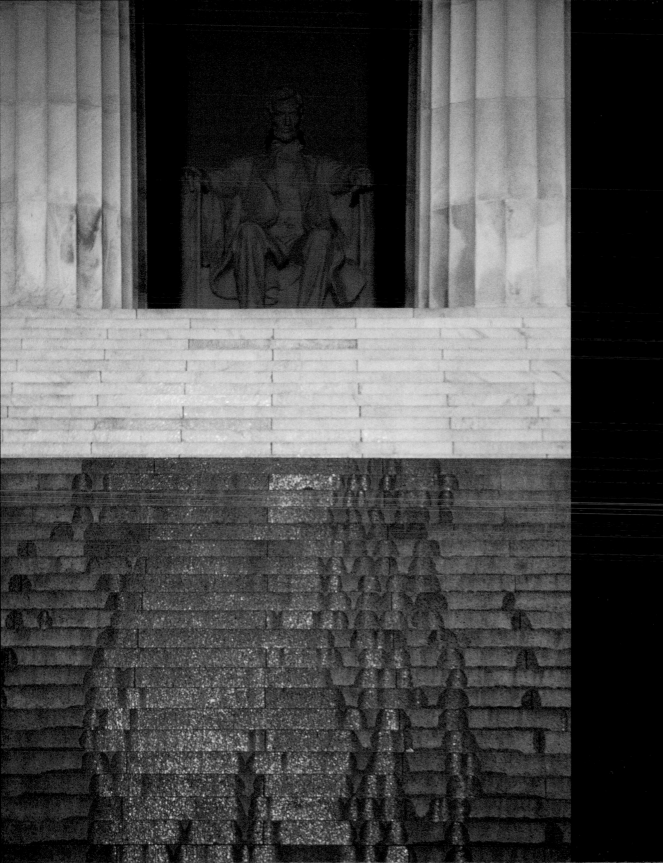

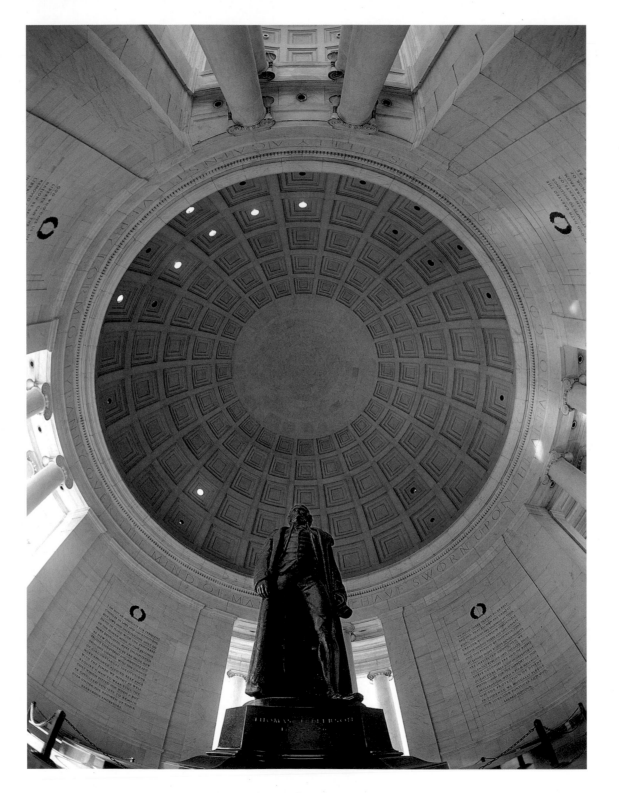

30 Jefferson Memorial

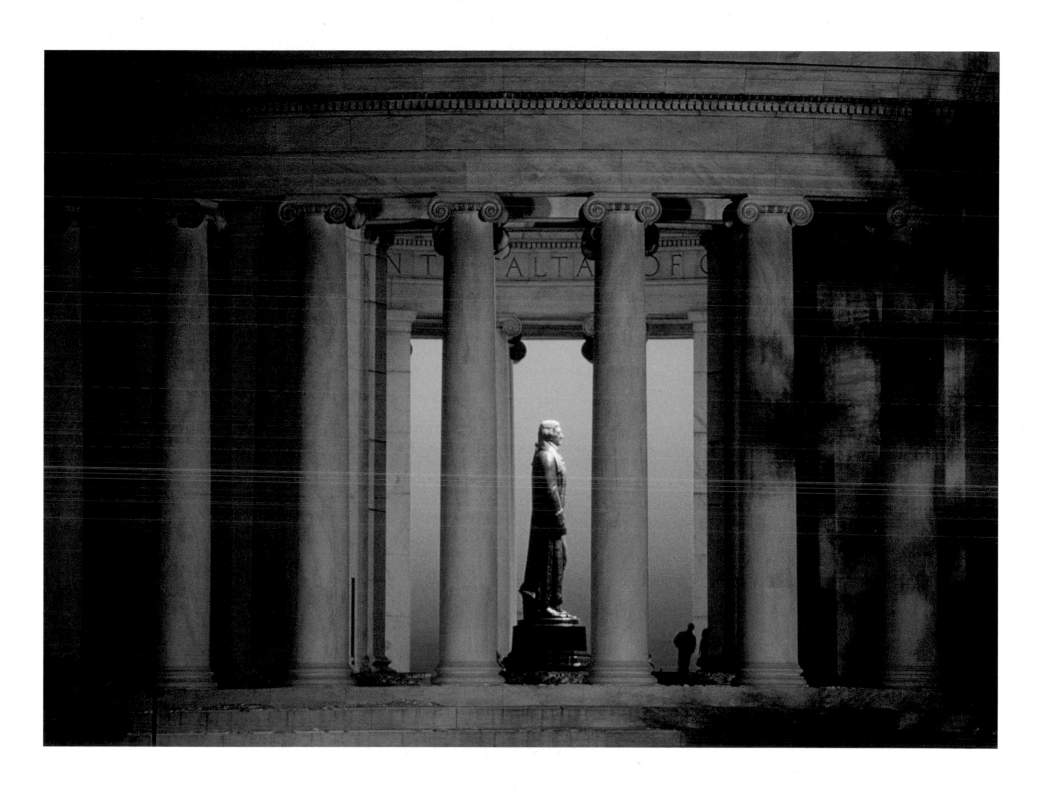

31 Jefferson Memorial at Sunset

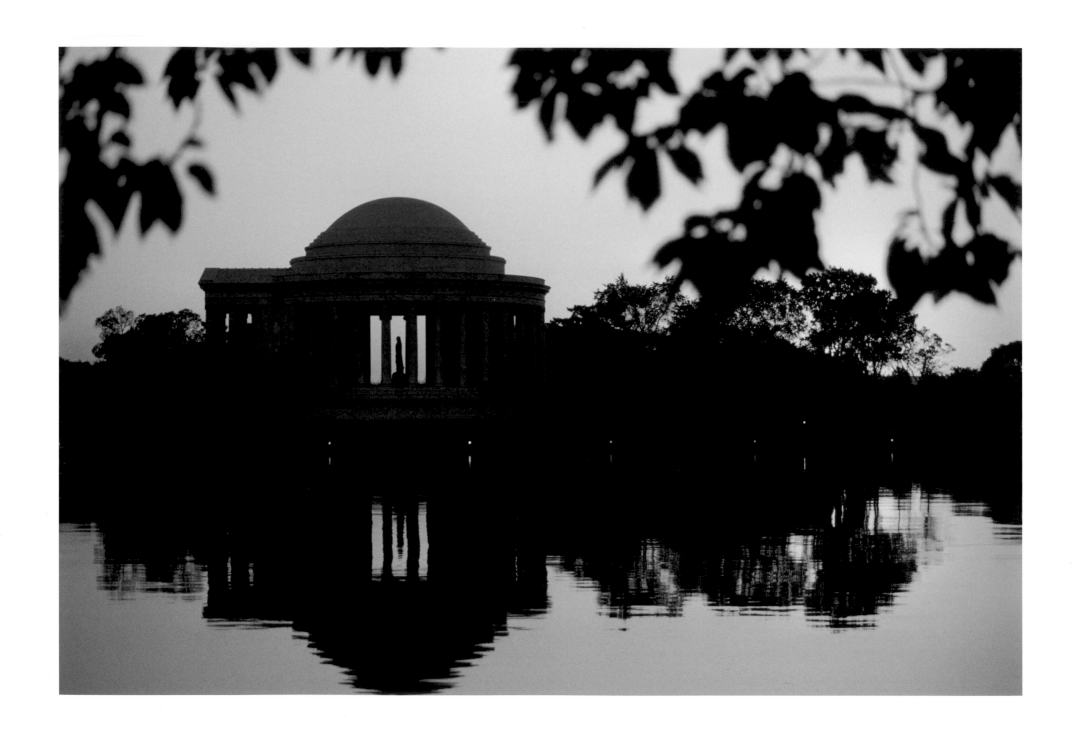

32 Jefferson Memorial at Sunrise

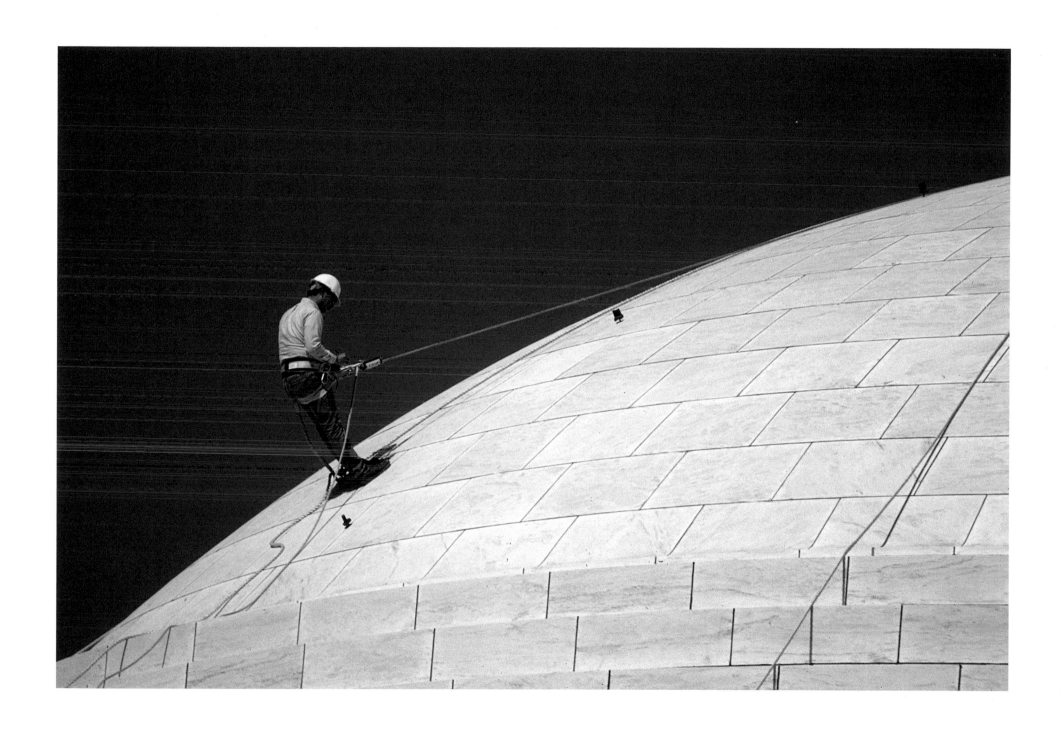

33 Jefferson Memorial Dome

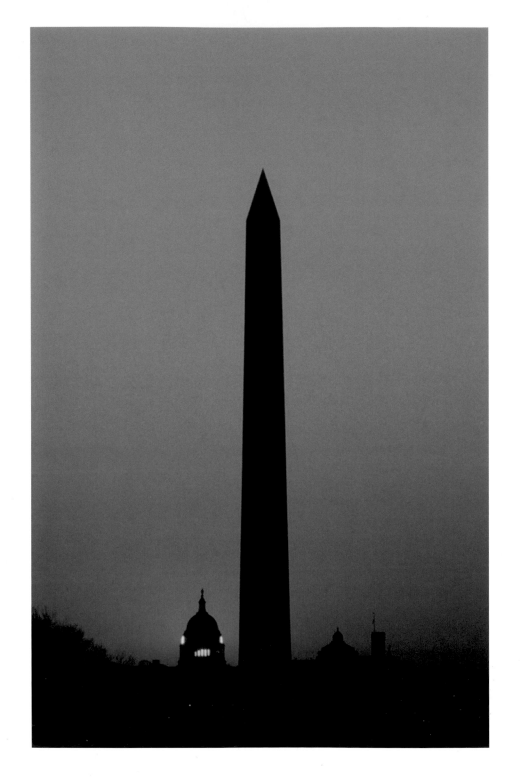

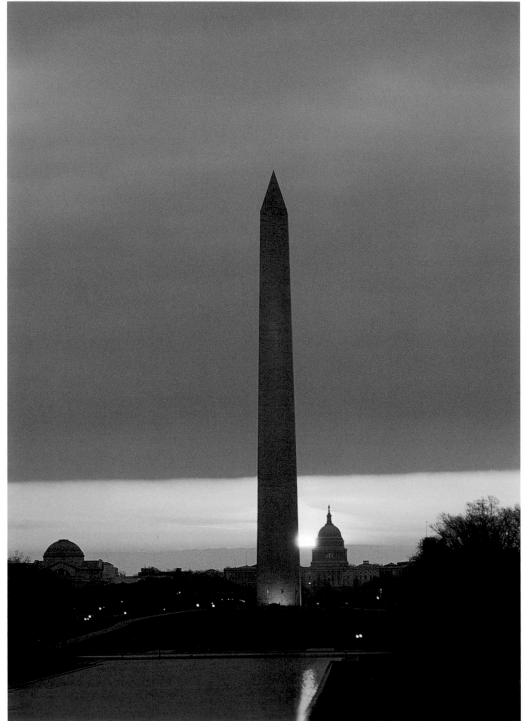

34 Washington Monument Sunrises

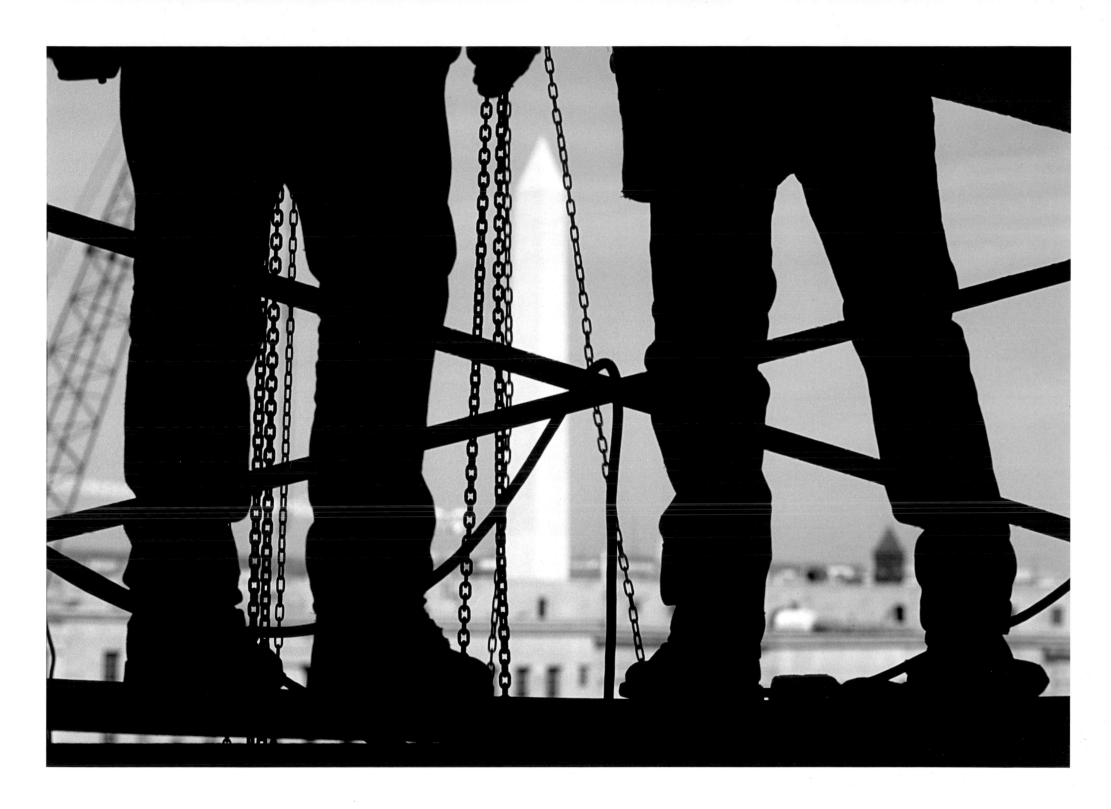

35 Construction Workers & Washington Monument

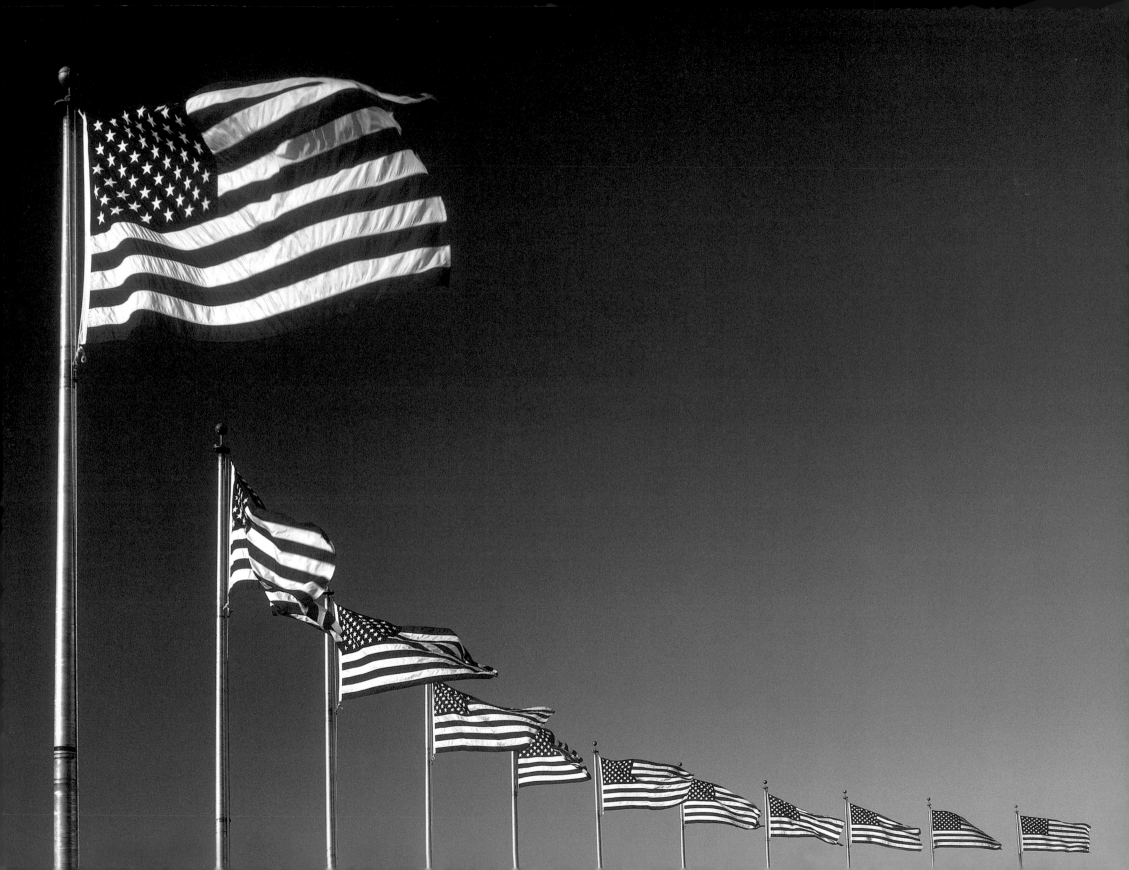

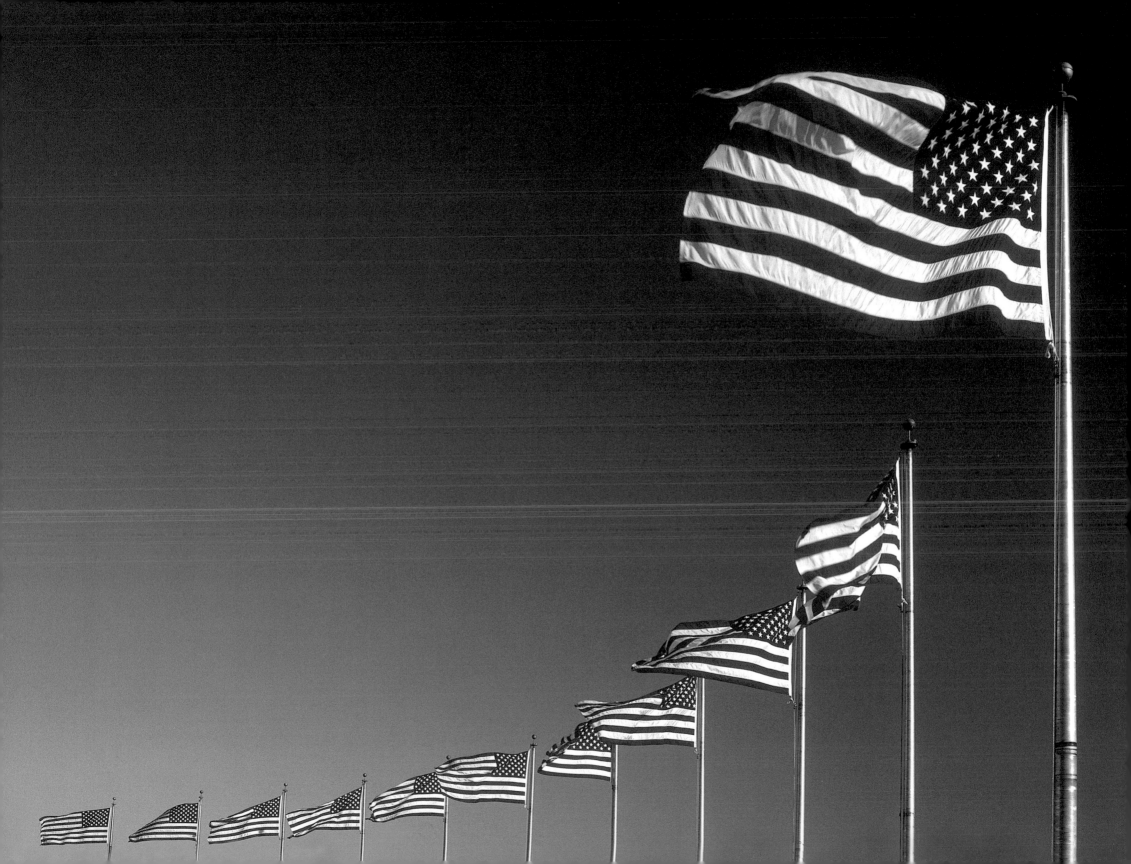

SCULPTURE & MEMORIALS

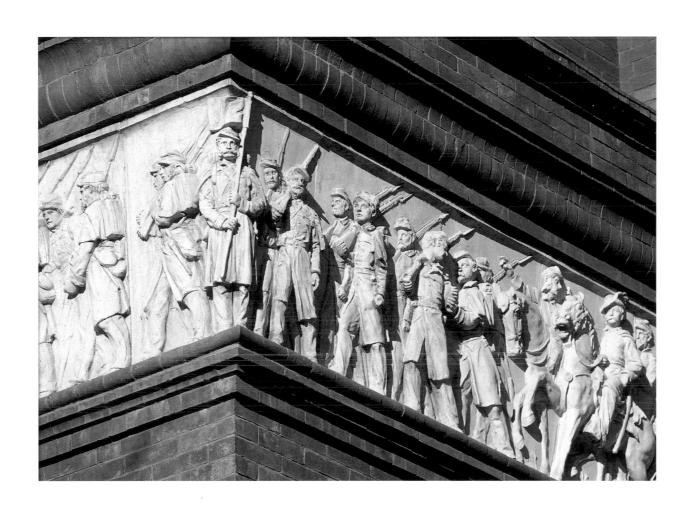

The Washington, Jefferson and Lincoln memorials are dominating presences on and, in the case of Jefferson, slightly off the Mall, but the nation's capital brims with other memorials. Most take sculptural form, making Washington far and away the most sculpture-rich city in the country, whether measured in quantity or quality.

A telephoto lens reveals the emotional power of the extraordinary frieze that wraps around the massive post–Civil War National Building Museum (39). On the west side of the Capitol, a stolid General Ulysses Grant is flanked by two emotional groupings of soldiers, one charging into battle, the other returning from it (41). This powerful sculptural triptych is a classic tale of the struggling artist. Henry L. Shrady spent decades creating his masterpiece, then went broke waiting for Congress, which commissioned it, to pay.

Congressional Cemetery, sitting placidly and obscurely in southeast Washington, is a treat for history buffs. It's home to many famous nineteenth-century figures, including enough congressmen to create a heavenly quorum (42). Arlington Cemetery (43,44) is the final resting place of the well-known, the little-known and the unknown. Arlington remains active to this day: I attended two burial ceremonies on these grounds while, incongruously, throngs of tourists passed by. Not far away, beside the Potomac River, the waves and seagulls of the Navy-Marine Memorial are surrounded by a large bed of tulips (45).

Felix de Weldon's iconic Iwo Jima Memorial commemorates one of the most horrific battles of World War II (46,47). This sculpture, based on an equally iconic photograph, is situated on a hill in Virginia that offers a dazzling vista of the city.

The strategic location of the World War II Memorial on the Mall more than makes up for its aesthetic limitations (48).

The Korean War Memorial, with sculpture by Frank Gaylord, II, is a powerful remembrance to a war largely forgotten but for the enduring TV show *M*A*S*H*. With the soldiers covered by ponchos, I thought it appropriate to take my photo in the rain (49).

The design of the Vietnam Memorial by architect Maya Lin was controversial when proposed, but now it is universally praised. Seen here with the Washington Monument reflected in its polished granite, the Memorial derives extraordinary poignancy from its profound "simplicity" . . . and because tens of millions of people deeply touched by that war are alive today (50).

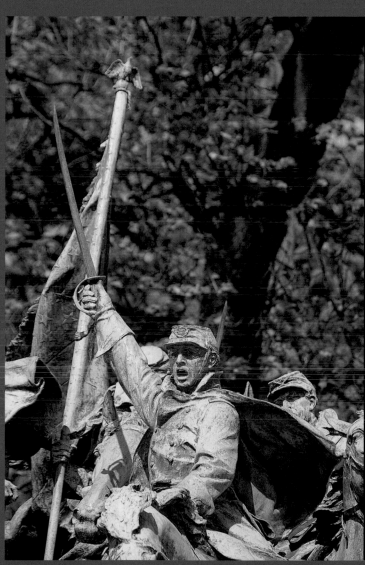
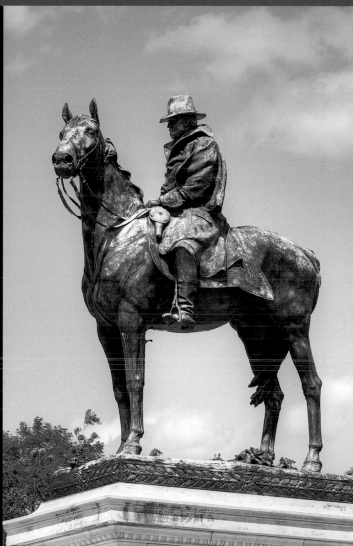
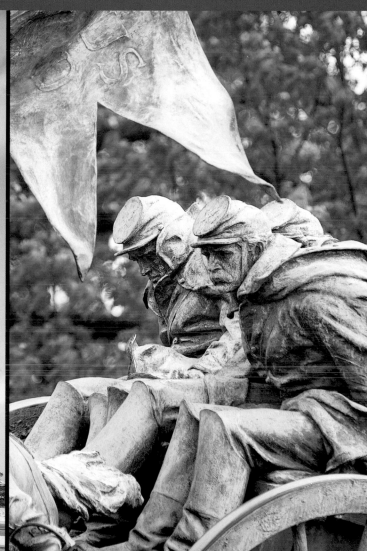

41 General Grant & Soldiers in front of U.S. Capitol

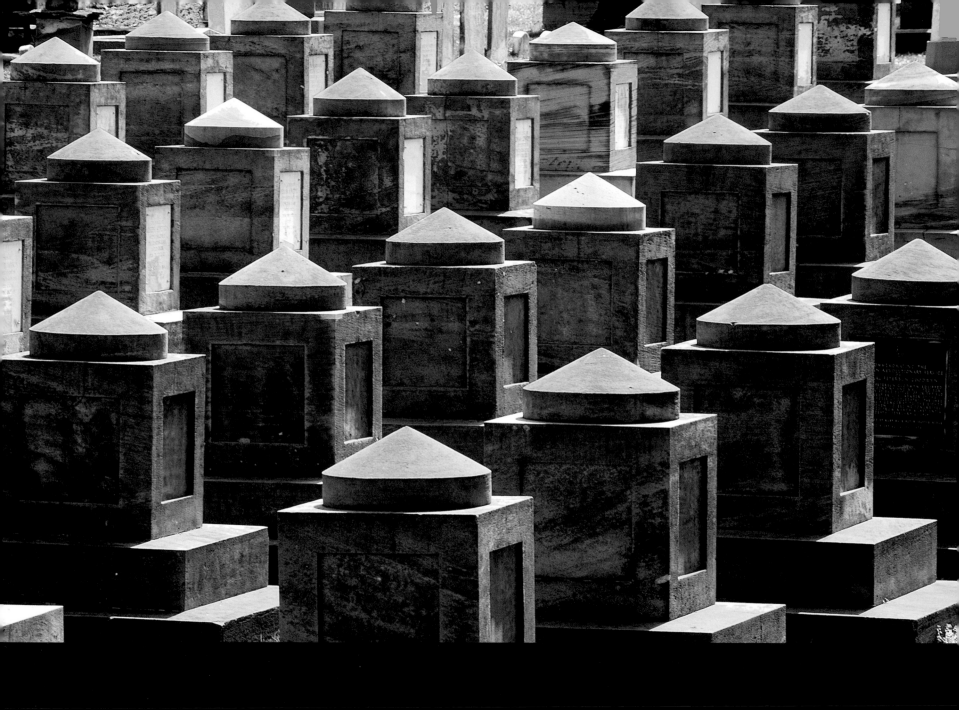

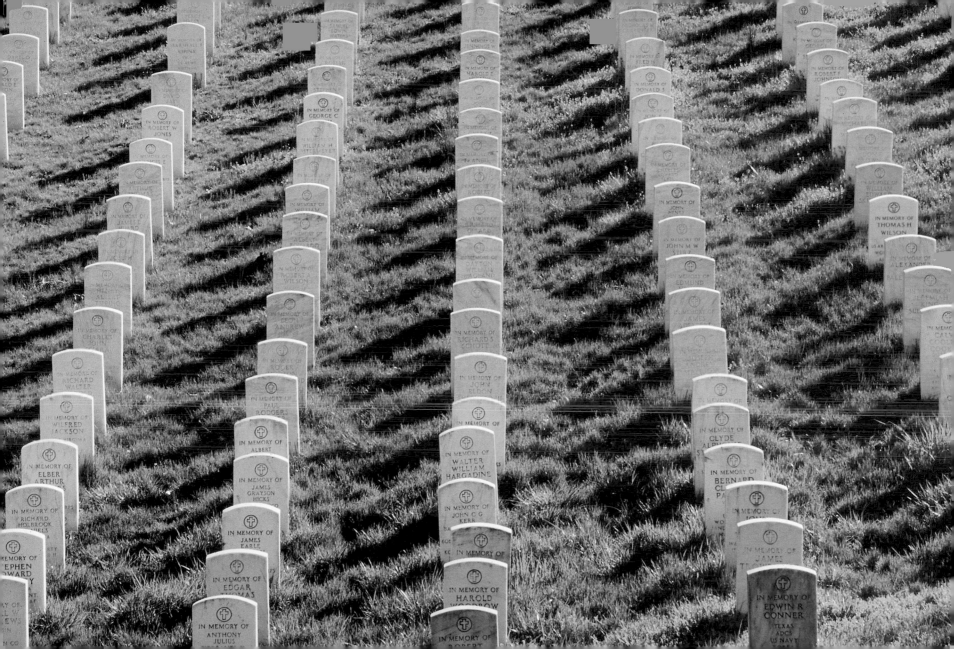

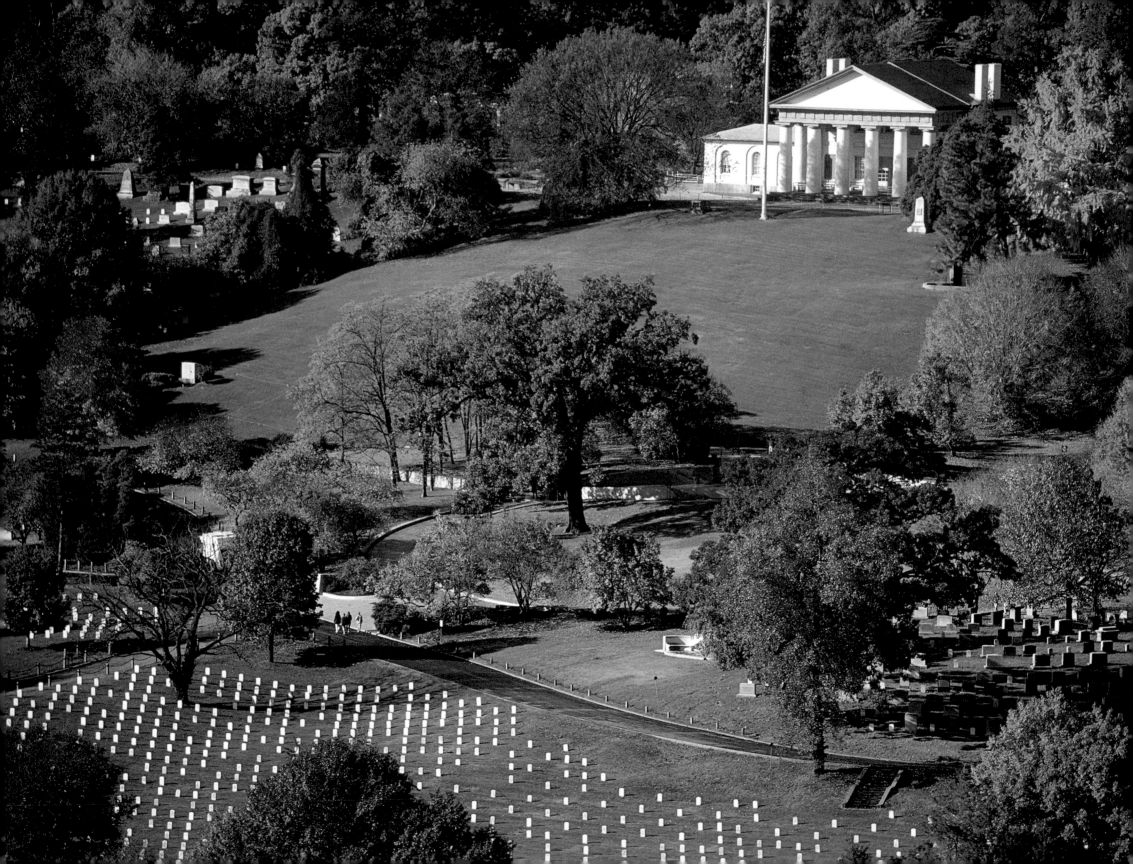

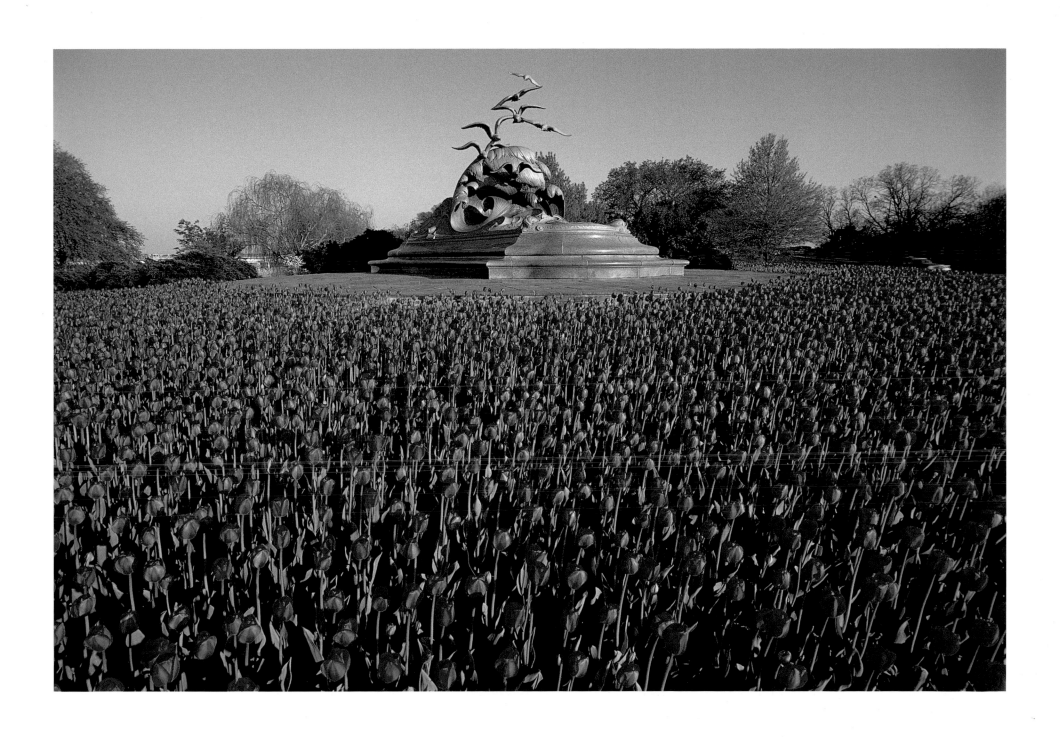

45 Navy-Marine Memorial [44 Arlington Cemetery]

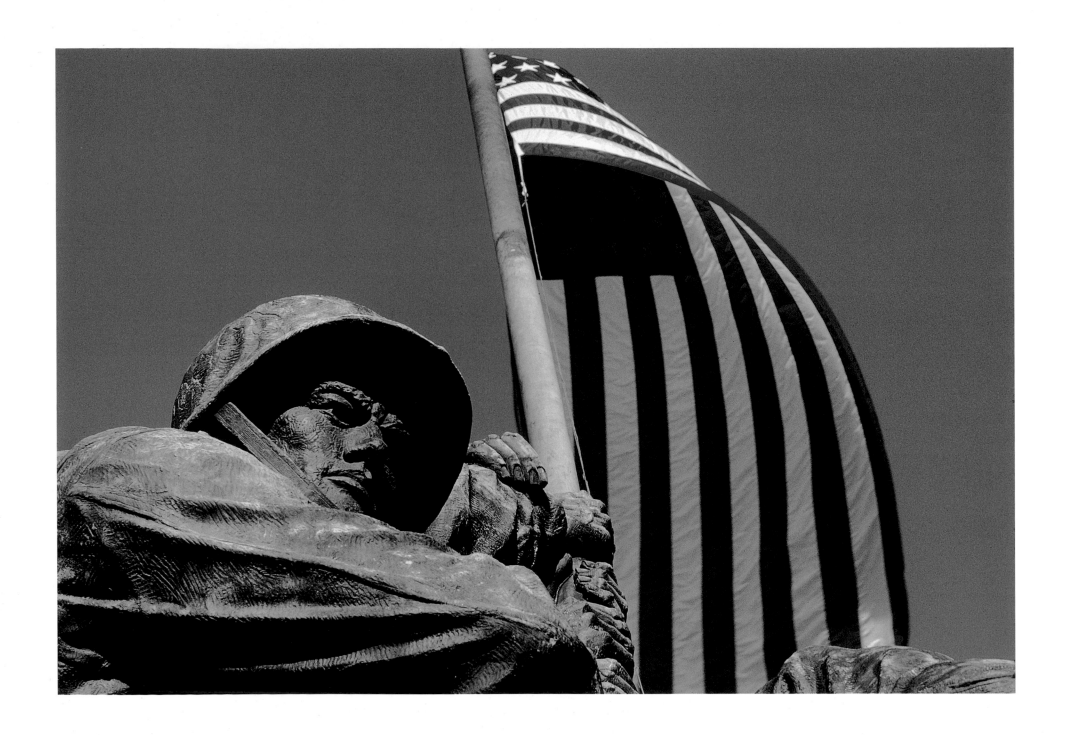

46 [47] Iwo Jima Memorial

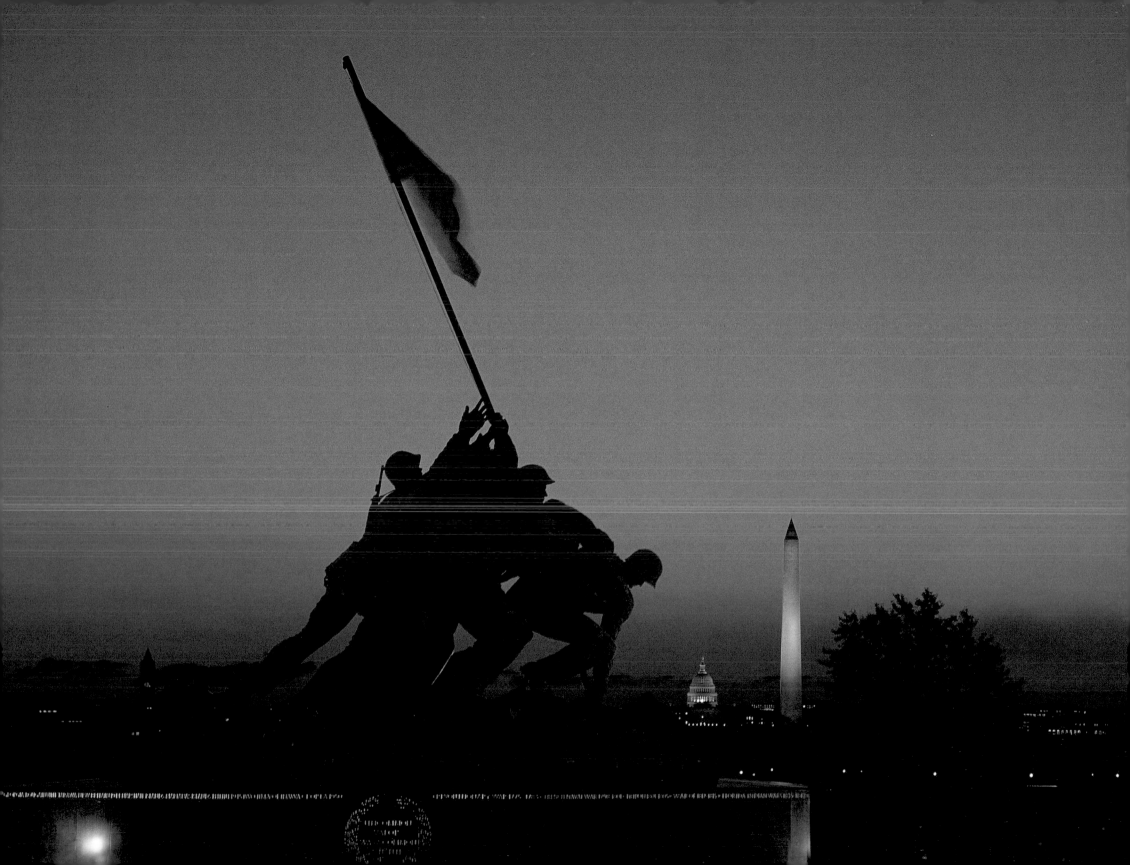

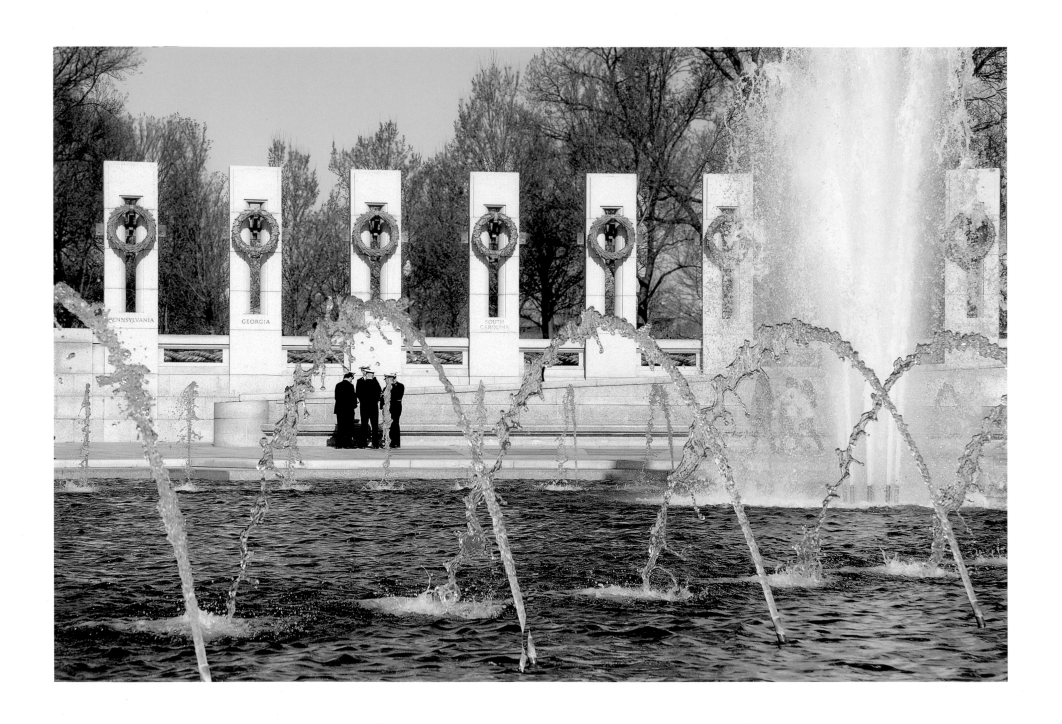

48 World War II Memorial

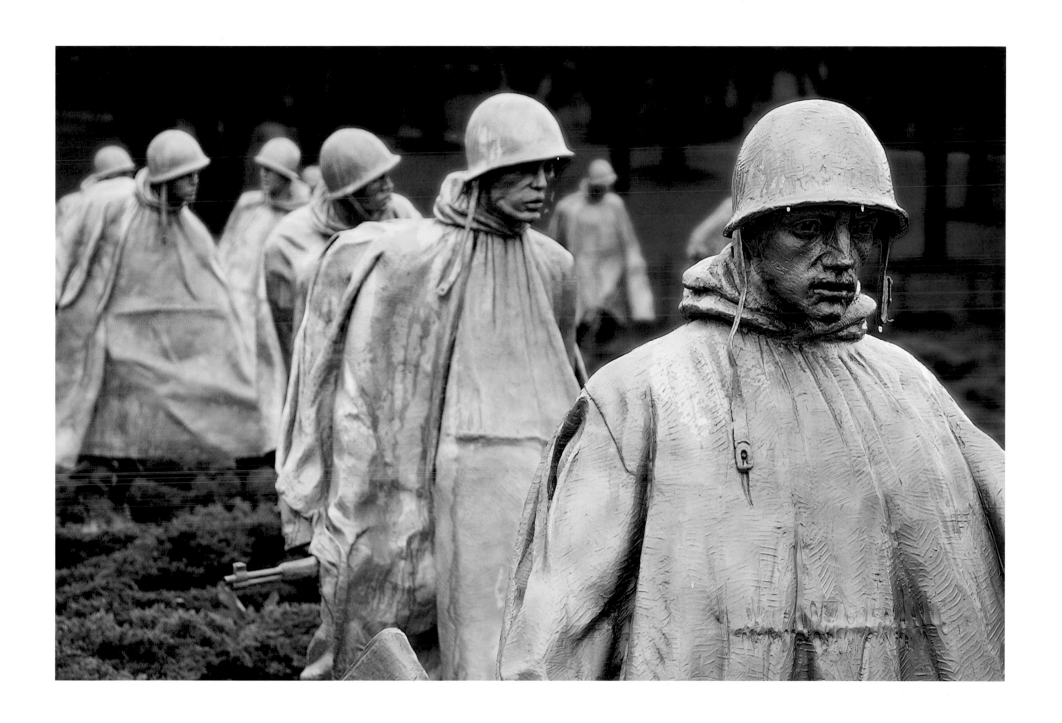

49 Korean War Memorial [50 Vietnam Memorial]

...ARD E CORO • RONALD B RUEPPEL • ...ALL R CLEMENTS...
...OBERT W WENDT • LEO F GRADY • DWIGHT H JONES • EDWIN A KUDLACEK...
...OVAN • FREDERICK C HEBERT • DONALD E PIERPOINT • ALBERT T BALL • CHRIS R BEHM...
...N R VINCENT • FREDERICK C HEBERT • GEORGE W KAMENICKY • RONALD G RICKS...
...URDE • ROBERT E THOMAS Jr • JEFFERY L WRIGHT • ROBERT E ELDRED • ROBERT H MAGGS...
...RY W CHANEY • ROBERT E THOMAS Jr • ROBERT O GOODMAN Jr • DAVID L HANN...
...ON • GERALD F McGLONE • SIDNEY A COTTRELL • GARY L MIZNER • JEFFREY R STOKES...
...IEL R HOFFMAN • JOSEPH M FEENEY • ADDISON W PAGE Jr • RAFAEL PEREZ-VERDEJA...
...Y • FRANKLIN ROSADO SILOS • JOSEPH M FEENEY • DAVID J FUNES • DENNIS R HINTON...
...AUDLEY D MILLS • JOHN S CHRIN • THOMAS J STANUSH • MICHAEL L DARRAH...
...IRVING J BROWN Jr • CARL S MERLINO • HUGO A GAYTAN • RICKY ALAN PATE...
...ARRY F MILLER • JACK E SEARING • EDDIE B HUBRINS • RALPH N LEE...
...DEPREO • LAUREN R EVERETT • HARRY O BOWLES • BARRY A BOWMAN...
...ERT M WEBB Jr • ROBERT J BARTON • DAVID R HOUSER • ALVIS T BARRINGTON Jr...
...S SHELTON • RICKY M ARIENS • PATRICK J BRESLIN • JOHN H BROWN...
...ER Jr • ROBERT N BROWN • ALAN R BOONE • WILLIAM E WHITEMAN II...
...O J PRIVITAR • WILLIAM A SHELTON • MARSHALL W WILLIAMS • BILLIE LEE COLEMAN...
...WILLIAM J MAKOWSKI • LARRY J PORTER • HERMAN C CAHOON • PAUL R FOLTZ...
...G BRANNON • DANNY A COWAN • DANIEL S SALAS • ROY D BARNES...
...E MAGGIO • ANTHONY J MENSEN • DANIEL G DYE • MAURICE E GARRETT Jr...
...CLIFTON • WALTER C FRISBIE • BILLY V MORRIS • NICK N RODRIGUEZ...
...HINNEY Jr • ELLIOT M YOSHIDA • LONNIE W MITCHELL • ANTHONY P QUINT...
...INGER • THOMAS F GREEN • BRUCE A ABDELLAH • MICKEY E EVELAND...
...T A NICKOL • JAMES C SKINNER • EDWARD L HIMES • MICHAEL LAUTZENHEISER...
...CLEVELAND • DAVID L JACKSON • STANLEY W TAYLOR • ALBERT R TRUDEAU...
...HN P CARR III • JIMMY L HAYNES • DONALD F VAUGHAN • JAMES C WAYNE...
...LS • KENNETH M BERBLINGER • LINUS L OAKLEY • GENE W STOCKMAN...
...RELL HOGAN • ERNIE ROBLES MARTINEZ • HARDY E CLEVELAND • MICHAEL M FARLEY...
...ALLMAN • LUTHER ...ARD Jr • ROBERT E RYAN • JAMES M S...
...RANK • STEPHEN J HUSKEY • GUFFEY S JOH...
...ALL • MICHAEL L HINO • JOSE MALDO...
...ERROL L KENT • ERNEST J MONT...
...DORITY • DAVID L GINN • HARVEY ...
...OUIS • JAMES R PANTALL • JE...
...DAVI...

Teddy Roosevelt's sculpture (52), on the little-visited Roosevelt Island in the Potomac, lacks the vibrance of the great president, but the island is a quiet respite from the city, which lies just short yards away. Franklin Delano Roosevelt's Memorial has some wonderful sculpture spread throughout a sprawling quarry of granite (53). (Note: The main FDR sculpture serves as backdrop for the author photo, page 142.)

The Capitol building's statuary hall, where each state is represented by two of its prominent sons and daughters, has wonderful pieces (54), while outside the Library of Congress, Roland Perry's "Neptune Fountain" is a stunning example of classical sculpture; the water, which hasn't flowed recently, brings shimmering sensuality to the figures (55).

The Columbus Fountain outside Union Station, designed by Lorado Taft to simulate the prow of ship, captures both the determination and longing that Columbus must have felt (56). Yet another exquisite fountain was created by French sculptor Frédéric-Auguste Bartholdi (of Statue of Liberty fame) (57); it is not only wonderful in itself, but serves as a needed visual distraction from the ghastly House office building that looms nearby.

A few other sculptural pleasures: A woman weeps near the U.S. Capitol; the Sphinx with the perplexing expression at the Scottish Rite Temple; Mahatma Gandhi in his spare attire (58). Lastly, Englishman James Smithson, whose relatively modest bequest led to the formation of the Smithsonian Institution; Albert Einstein outside the National Academy of Sciences; and American educator Mary McLeod Bethune, located on Capitol Hill (59).

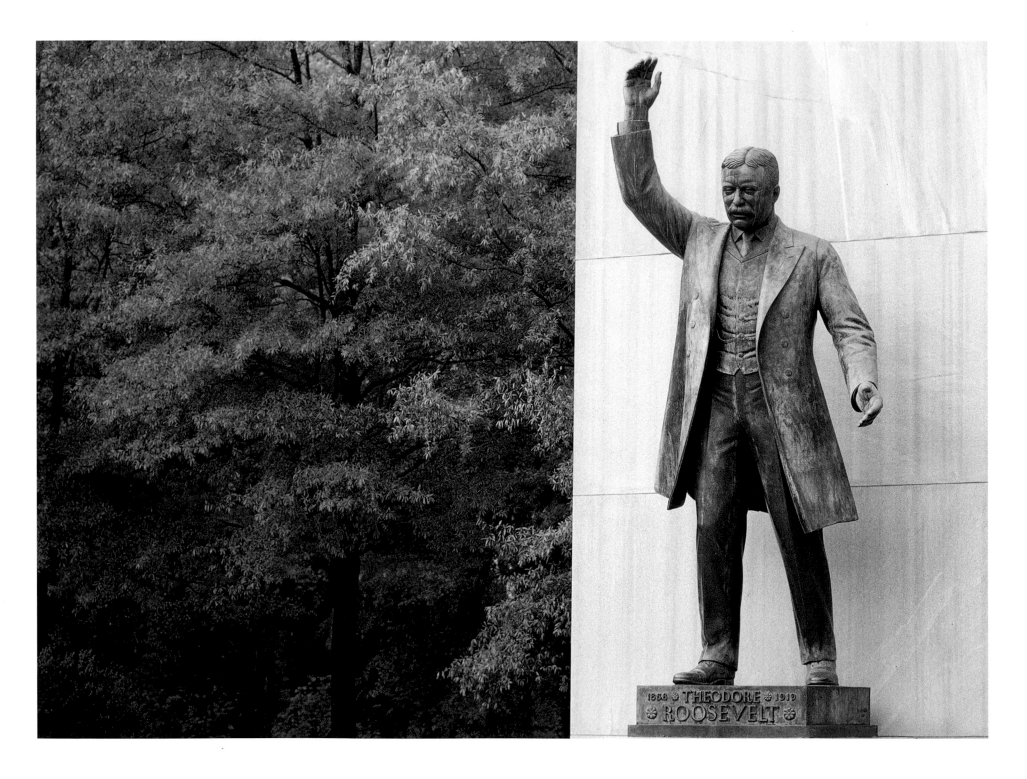

52 Theodore Roosevelt Memorial

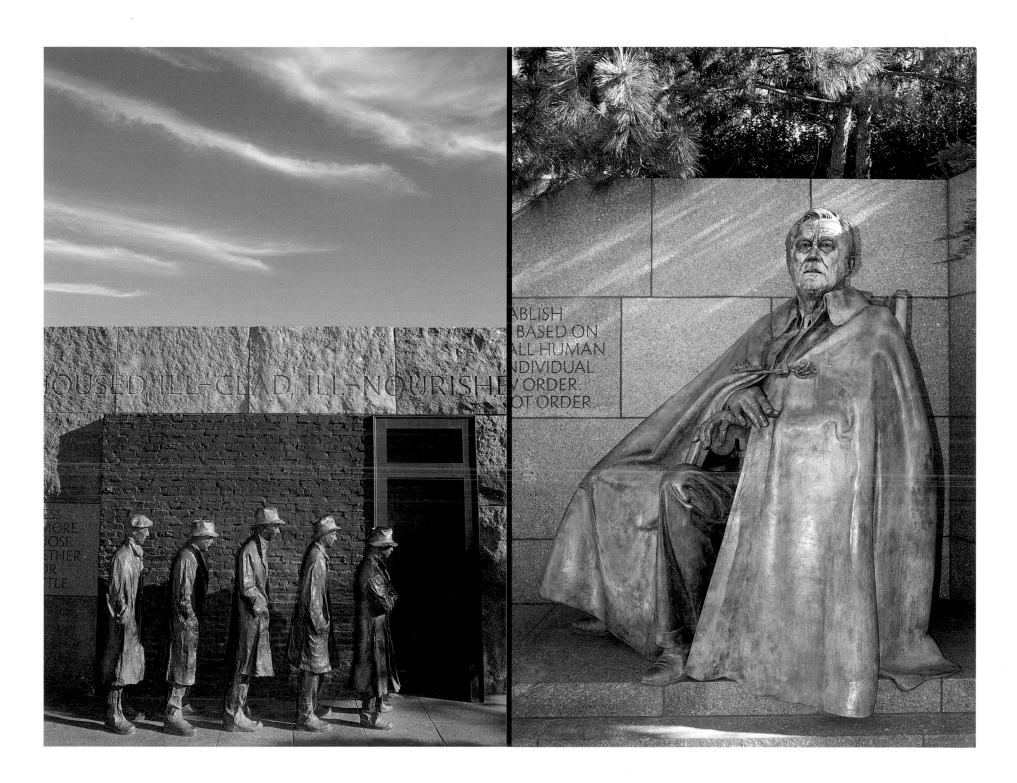

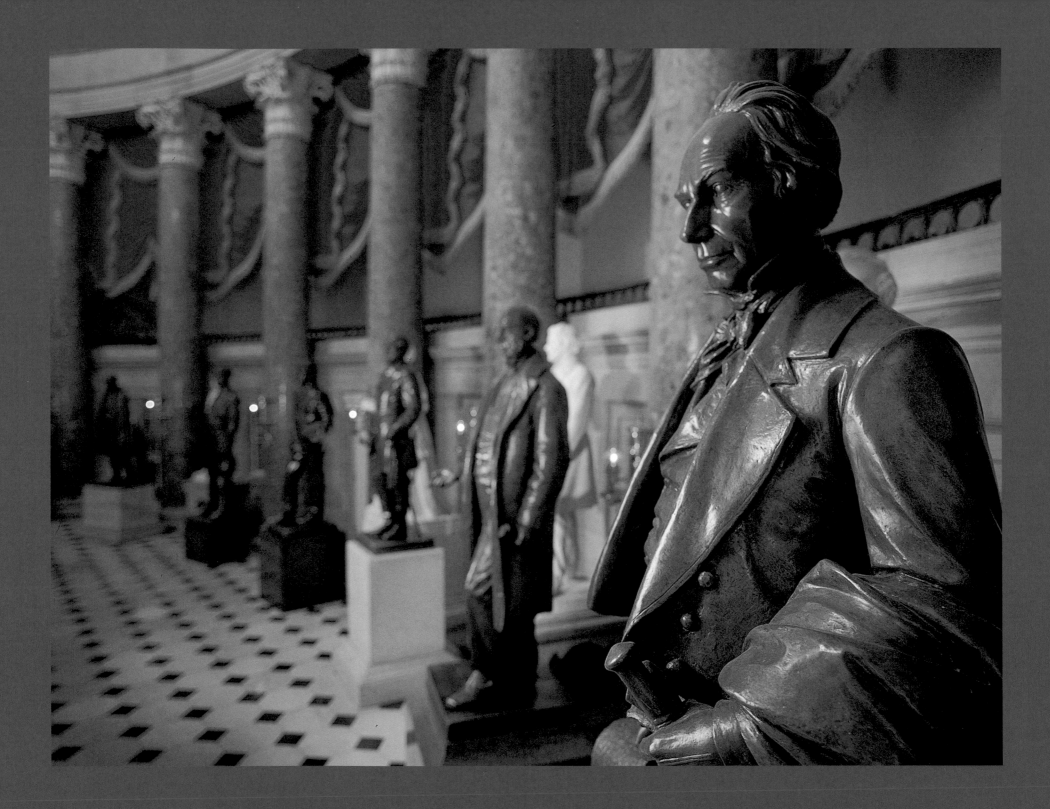

54 Statuary Hall, U.S. Capitol

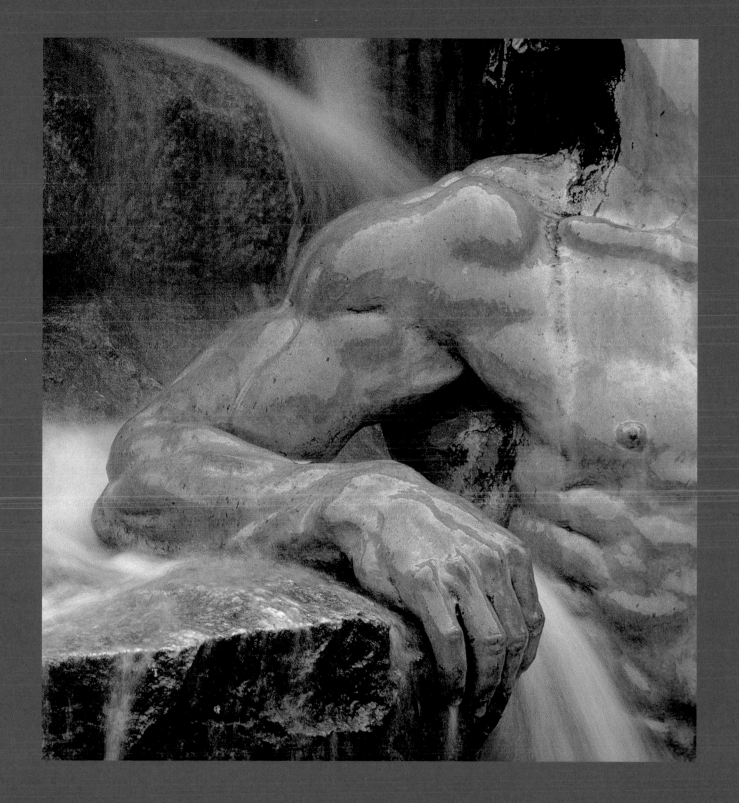

55 Court of Neptune Fountain, Library of Congress

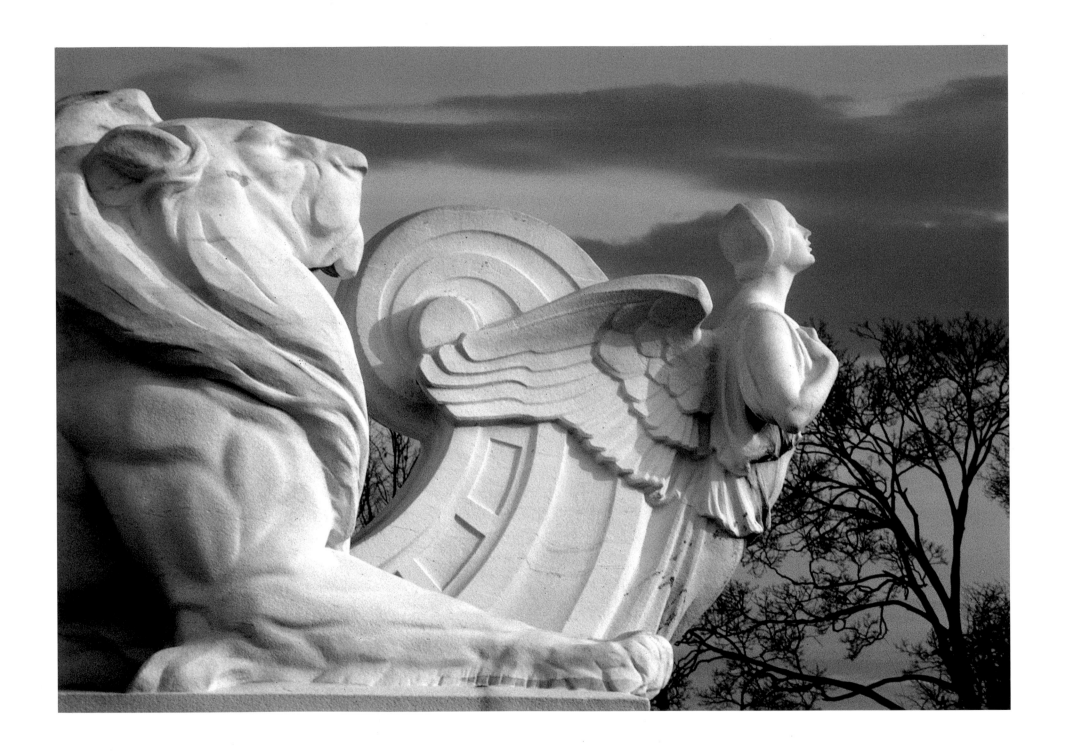

56 Columbus Fountain, Union Station

57 Bartholdi's Fountain, Botanic Gardens

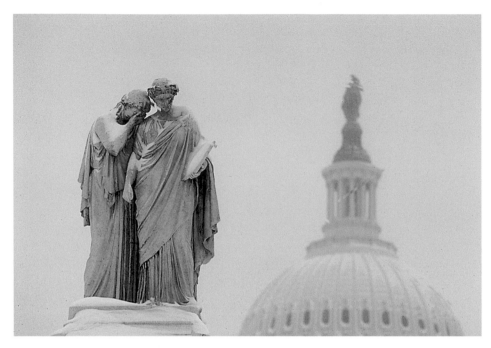

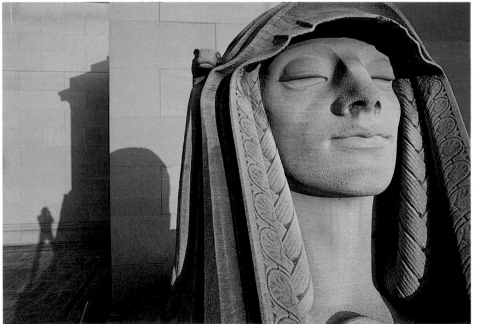

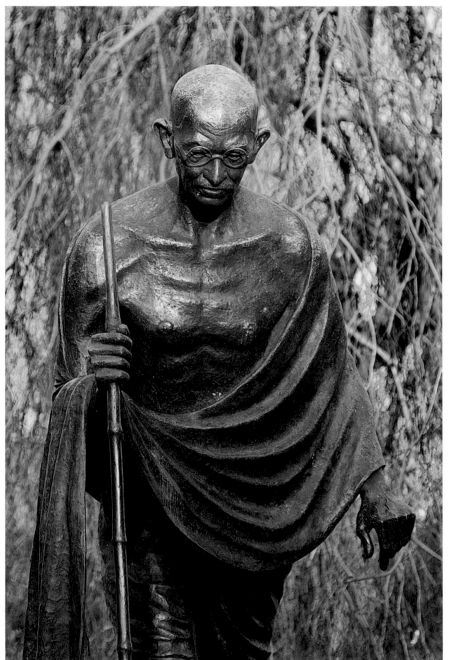

58 Grieving Woman; Sphinx, Scottish Rite Temple; Ghandi

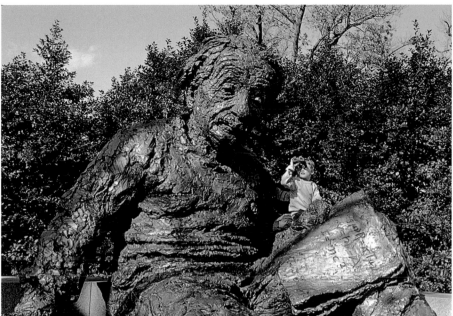

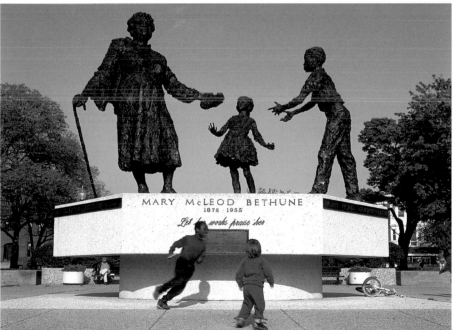

59 James Smithson; Albert Einstein; Mary McLeod Bethune

THE FEDERAL CITY

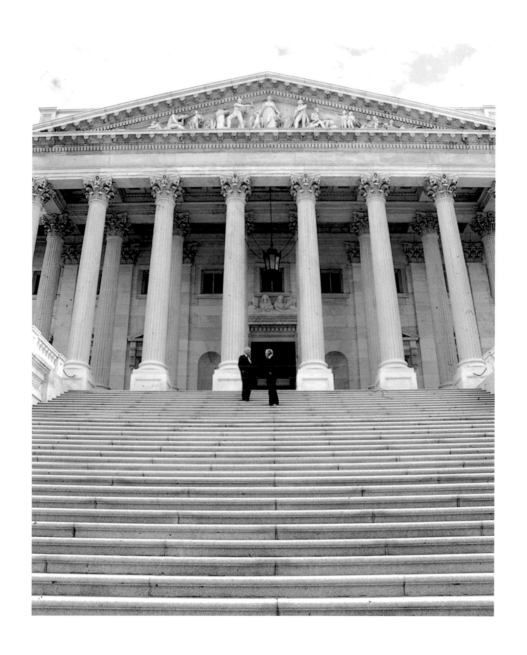

The buildings of the Federal City are not simply government symbols or formidable architectural objects. They are places where people work . . . where, once upon a time, I worked. Nearly ten years as a Washington lawyer found me, at one time or another, inside most of the buildings pictured in this chapter.

I've been inside the Capitol many times; I've even testified before several congressional committees. My feelings about the political process in Congress—and other branches of government for that matter—is best captured in a photograph of the ground floor exterior of the east side (63): solidity, majesty, mystery, intrigue, darkness and light.

I photographed two United States Senators from different parties for a magazine cover in the late 1980s (64). They laughed easily in each other's company; it's hard to imagine that happening these days. The Capitol Police generally combine a helpful approach with a reserved, stern demeanor (64).

I have photographed the Capitol inside and out in all seasons. Lincoln under the dome (page 2) gives a sense of the grandeur of the interior space. The Capitol in snow gives the place a feeling of cleanliness and innocence (65). Capitol sunset was taken from a very unusual vantage point: the pinnacle of the Supreme Court roof (66).

The Great Hall in the main building of the Library of Congress is, I would argue, the most exquisite interior space in the entire city (67). It's commonly said that the Library of Congress contains most of the world's published books. Does that mean that a person with a library card can take this book out for three weeks? (Personal note: If you're interested in jazz music, my father's world-famous photographs of musicians are housed in the Library. Search: William Gottlieb and Library of Congress.)

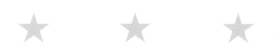

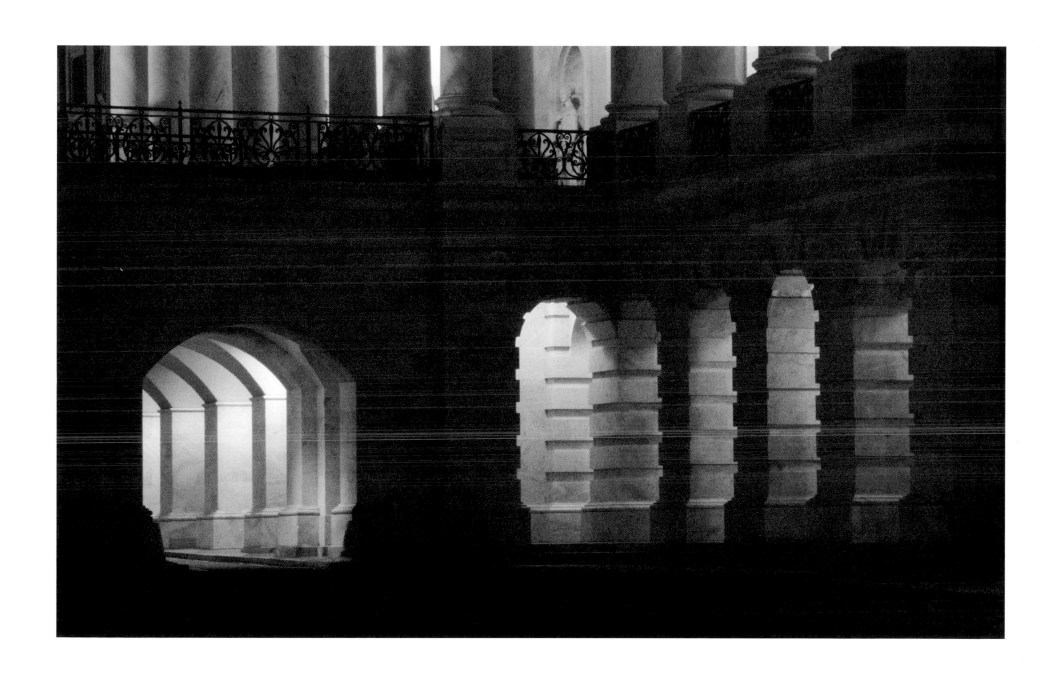

63 East Façade, U.S. Capitol

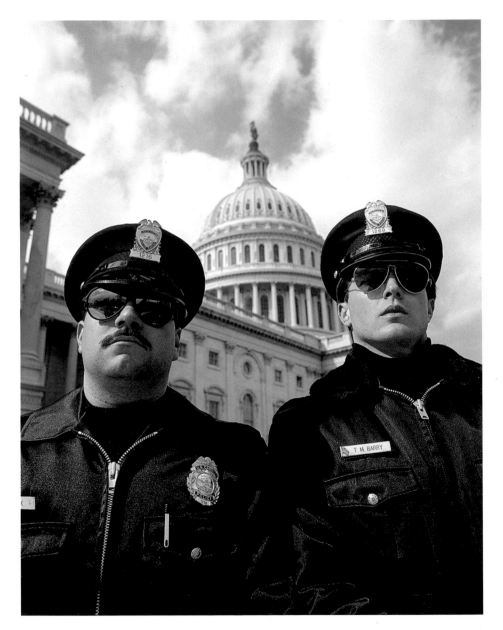

64 Senators; Capitol Police

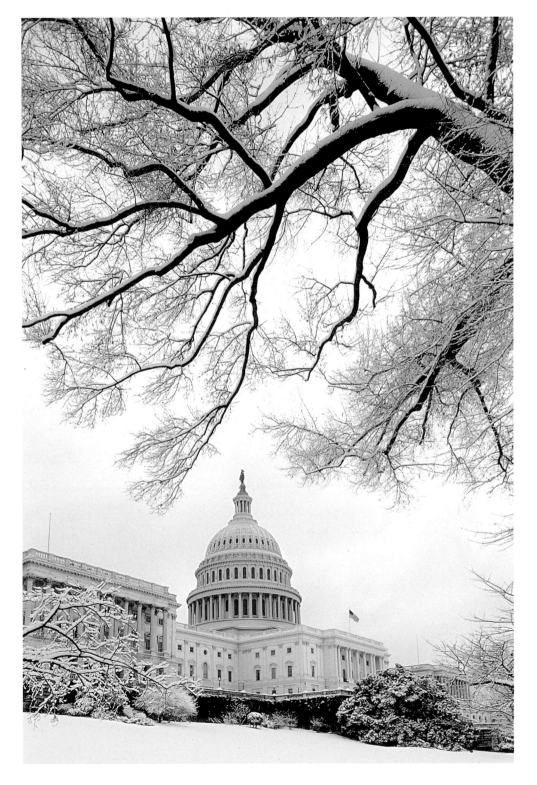

65 Capitol [66 Capitol from U.S. Supreme Court; 67 Great Hall, Library of Congress]

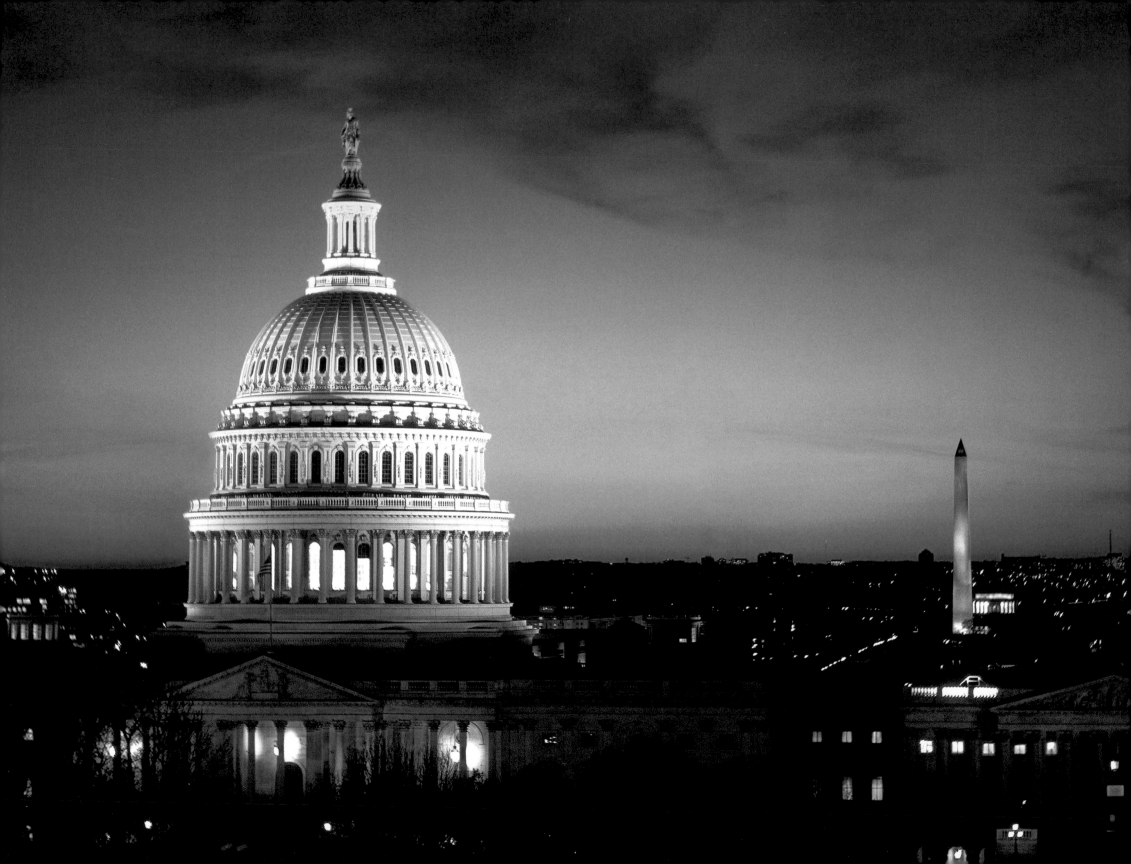

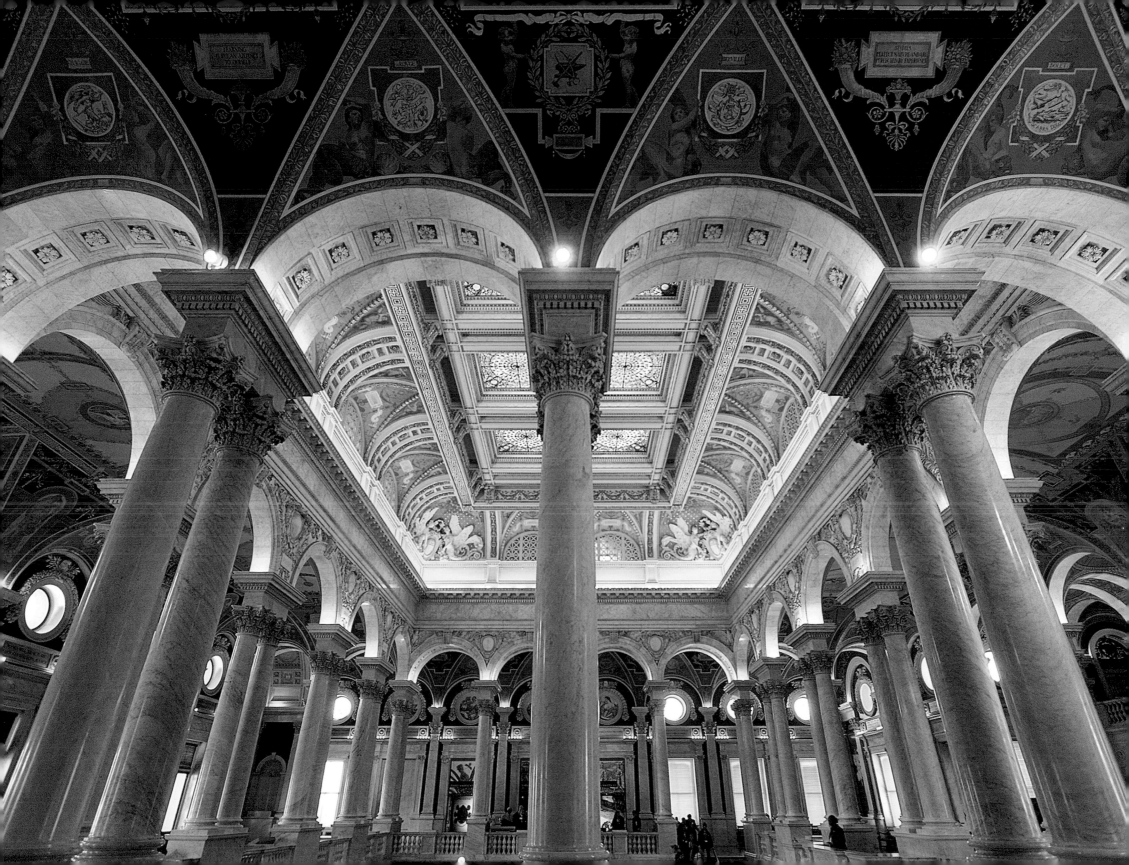

As a representative of the government agency where I worked, I once sat at counsel's table during a Supreme Court oral argument. I didn't utter a single word, but it was still a memorable occasion, not only because of the setting, but because the person I sat next to, and who argued the case for our side, was then–Solicitor General Robert Bork—who was doubly (in)famous: first, as the government official who fired Watergate Special Prosecutor Archibald Cox (who was investigating President Nixon's malfeasance), and second, as perhaps the most highly qualified person in American history ever to be rejected by the Senate for a seat on our highest Court.

Three views of the Court show, first, the Court in springtime (69), and next, a detail of the pillars (70). When I set up to photograph those pillars, I wanted a person in the picture. The sun was just about to set, so I raced down to the street and stopped a pedestrian.

"Could you spare a couple of minutes and pose for me up by the Court?" I asked.

"You don't want me in the picture," he said. "I'm an accountant . . . you need a lawyer."

"All I need is a man in a suit with a brown attache case," I begged.

"It's just not right to put an accountant in your picture," he said as he began to walk away.

"Look, I need you for just three or four minutes. I'll pay whatever you want."

"Gee, this must be really important. Okay, I'll do it." He never asked for money.

Last, a view of the Court at sundown (71). The sculpture was in shadow, but sunlight give the façade a warm glow.

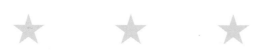

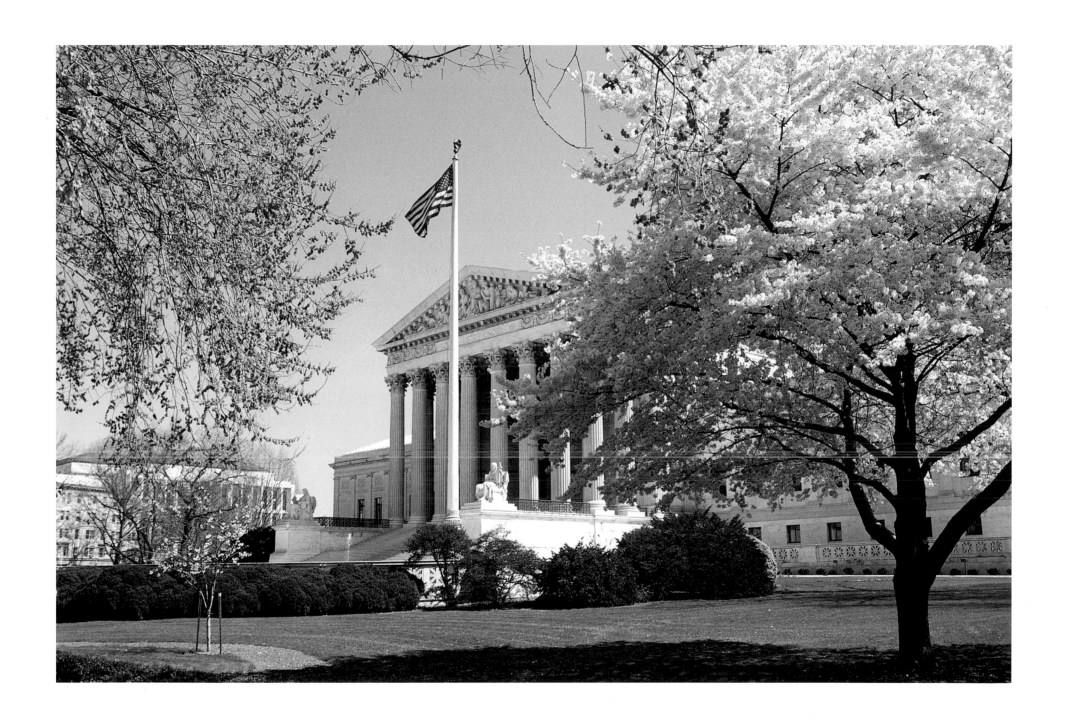

69 U.S. Supreme Court

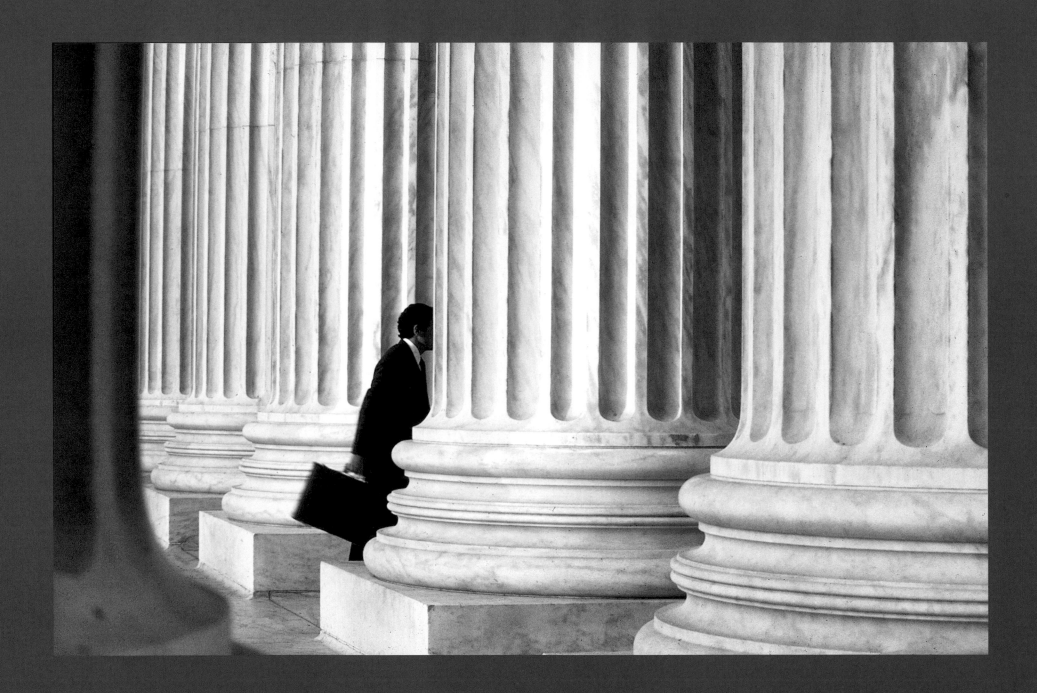

70 Supreme Court Entrance [71 Supreme Court West Façade]

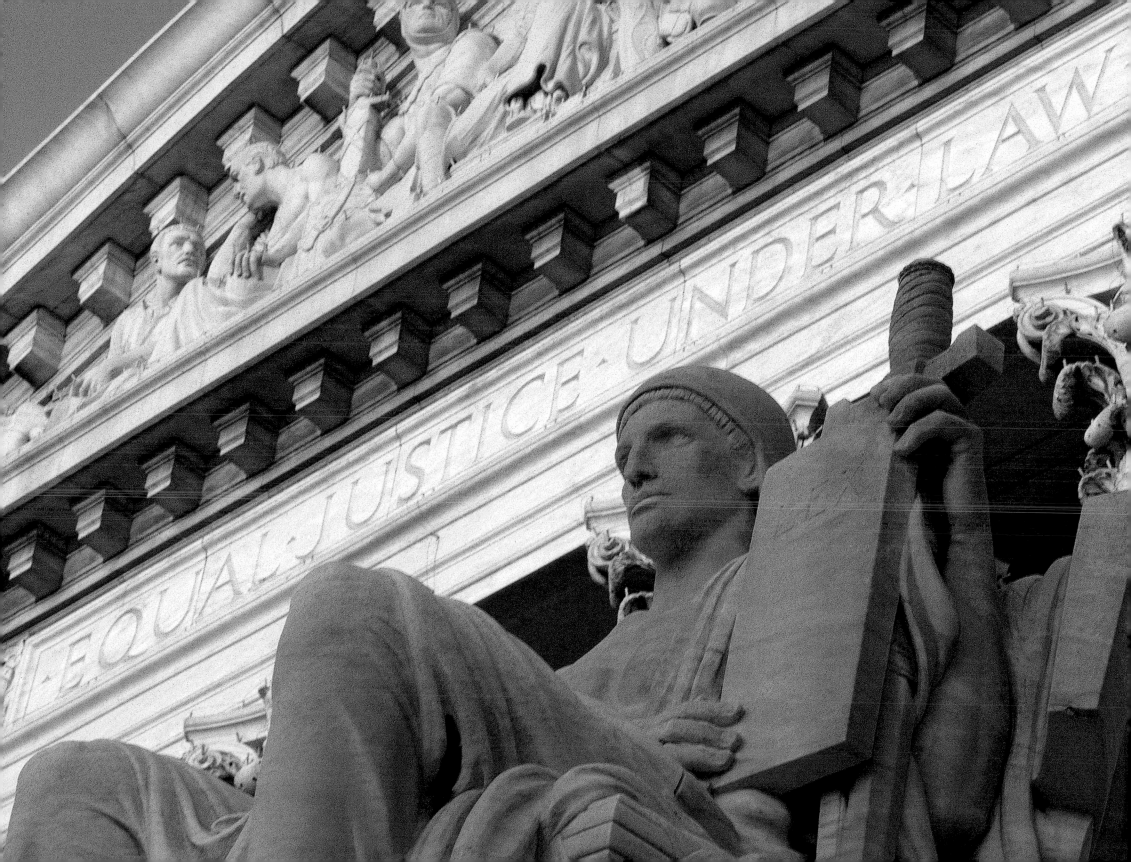

When I first arrived in Washington, I worked at the Office of Management and Budget, a small agency that works very closely with the White House. For this young OMB lawyer, proximity to power turned the trivial into the indelible, to wit:

1. I walked the few steps from my office in the Eisenhower Executive Office Building (73) to the White House and I arrived several minutes early for my very first meeting there. Naturally curious about my surroundings, I decided to take a brief self-guided tour around the periphery of the Roosevelt Room. Three-quarters of the way around, a man lunged out of an unseen recess and grabbed me from behind.

"What the hell are you doing here," he said in a cold whisper as he clenched me in an immobilizing embrace.

"I'm early for a meeting in the Roosevelt Room and I . . ."

"Well get the hell back in there," he interrupted as he released his threatening grip, "and don't ever let me catch you taking a casual walk outside the Oval Office."

2. Being a serious tennis player, working near the White House, and having the appropriate security clearance landed me regular invitations to play on the White House tennis court. The court is hidden behind a cluster of holly trees near the West Wing. One particular day, my duffer doubles partner, a high-ranking government guy, hit a wild shot that landed way out on the White House South Lawn. Etiquette dictated that as the junior member of the group I should retrieve the ball. Trotting out on the grass in my white shorts with racquet in hand, I looked over to see a large cluster of tourists excitedly pointing their fingers through the fence, gawking at me as if they'd spotted a rare nocturnal animal in bright daylight. Many years later, standing where those tourists were standing, an Asian family was happy to strike a classic pose for me at this classic location (75).

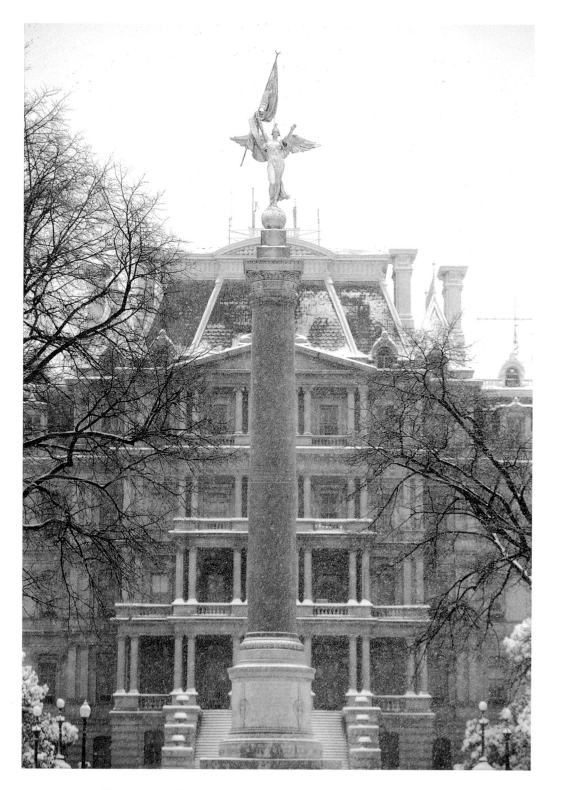

73 Eisenhower Executive Office Building

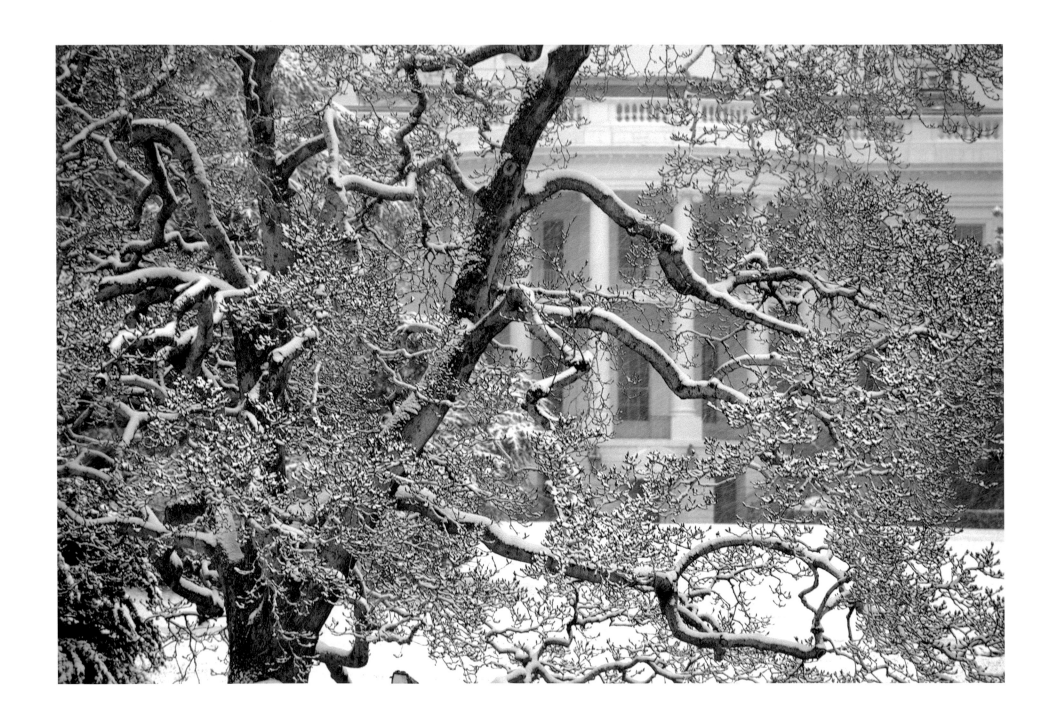

74 White House South Façade

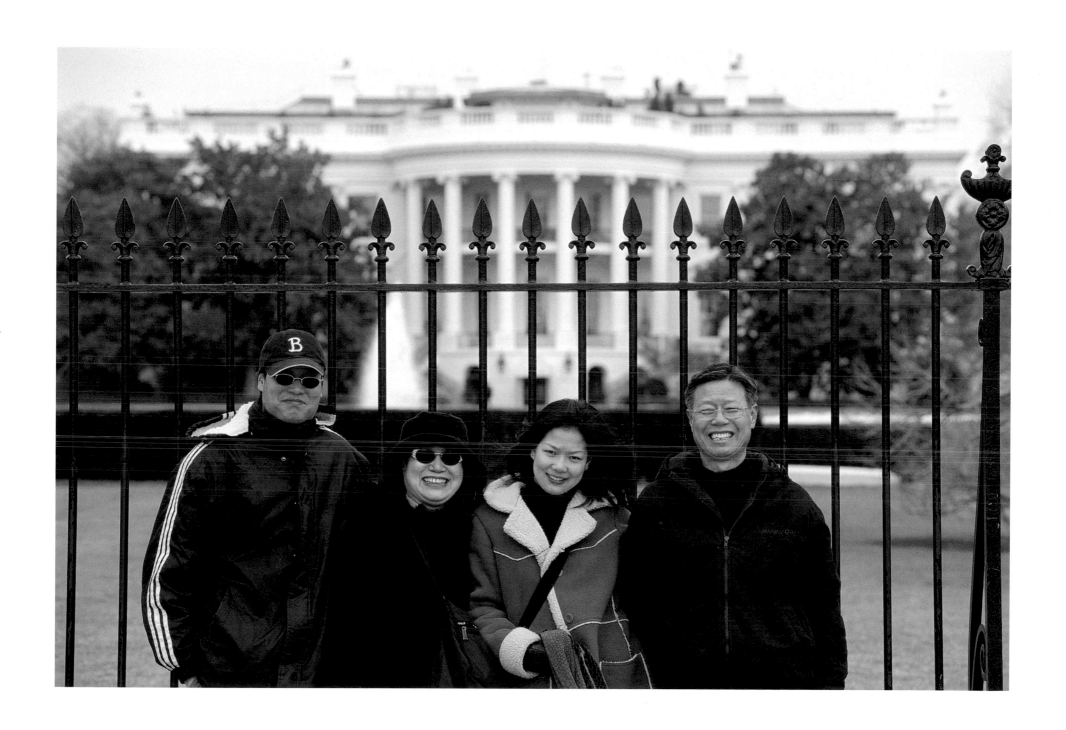

75 Tourists at the White House

The President sits atop a vast array of executive branch cabinet departments and agencies, sub-departments and sub-agencies, not to mention commissions, councils, and advisory boards. During my initial OMB General Counsel staff meetings I was lost in an acronym wilderness: "Who's following up with EPA and CEQ about Interior's NEPA problem?" "Has OLC conferred with the SG's office about that impoundment case?" "Steve, better ping on SBA about that 8(a) proposal."

During my years behind the thick glass and concrete and granite walls of executive branch buildings, I became relatively fluent in government-speak, but what was spoken was almost invariably forgettable, at least to me. I did, however, witness a memorable moment when the essence of the political bureaucracy shone with a sparkling, contorted light. Here is a verbatim portion of a transcript from a pre-trial deposition in which I represented a government official who was being questioned by the plaintiff's attorney.

Attorney: Do you know anything about the budget appropriation for this program?

Government Witness: No, I don't.

Attorney: If you don't know, do you know anyone who would know?

Witness: No, I don't.

Attorney: OK then, would you know someone who would know someone who would know?

Witness: Yes, I guess I would know who would know.

Attorney: Ah, now we're making progress. So tell me who would know who would know.

Witness: I'm all confused. That's not the kind of question I can answer.

Attorney: Now I know why Gilbert and Sullivan, or at least one of them, left law for operetta.

I chose photography rather than operetta as my escape vehicle from lawyering. It was a good choice. I found far more satisfaction photographing buildings than lawyering inside them.

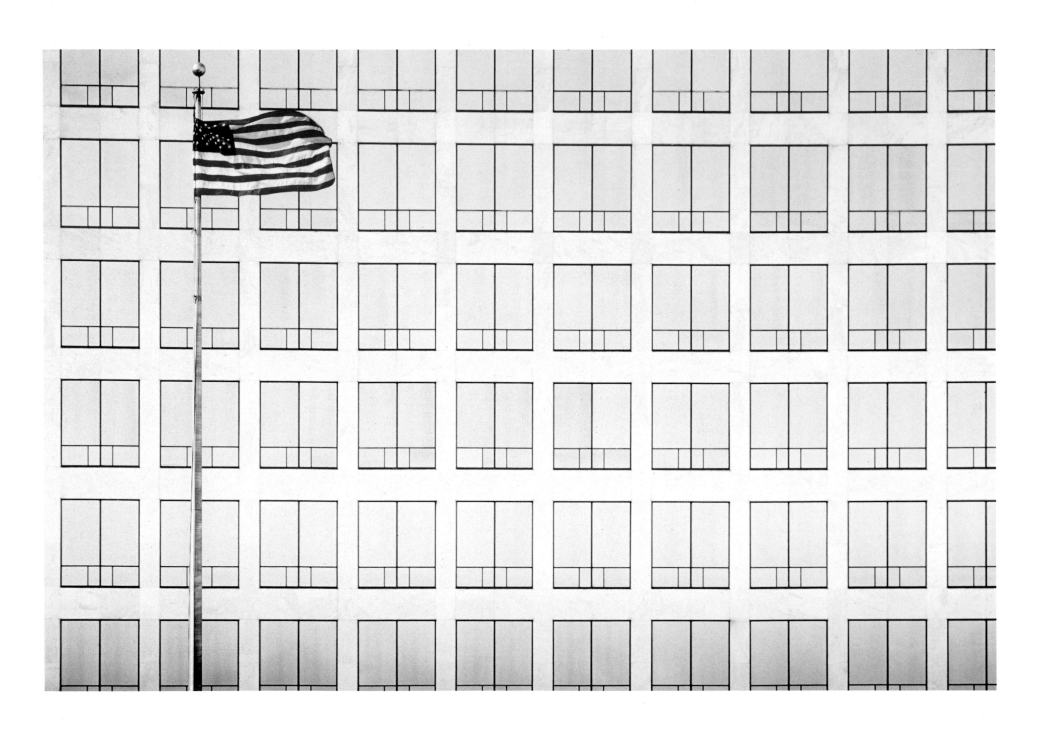

78 Federal Aviation Administration
[76 Housing & Urban Development through Car Window; 79 Department of Energy]

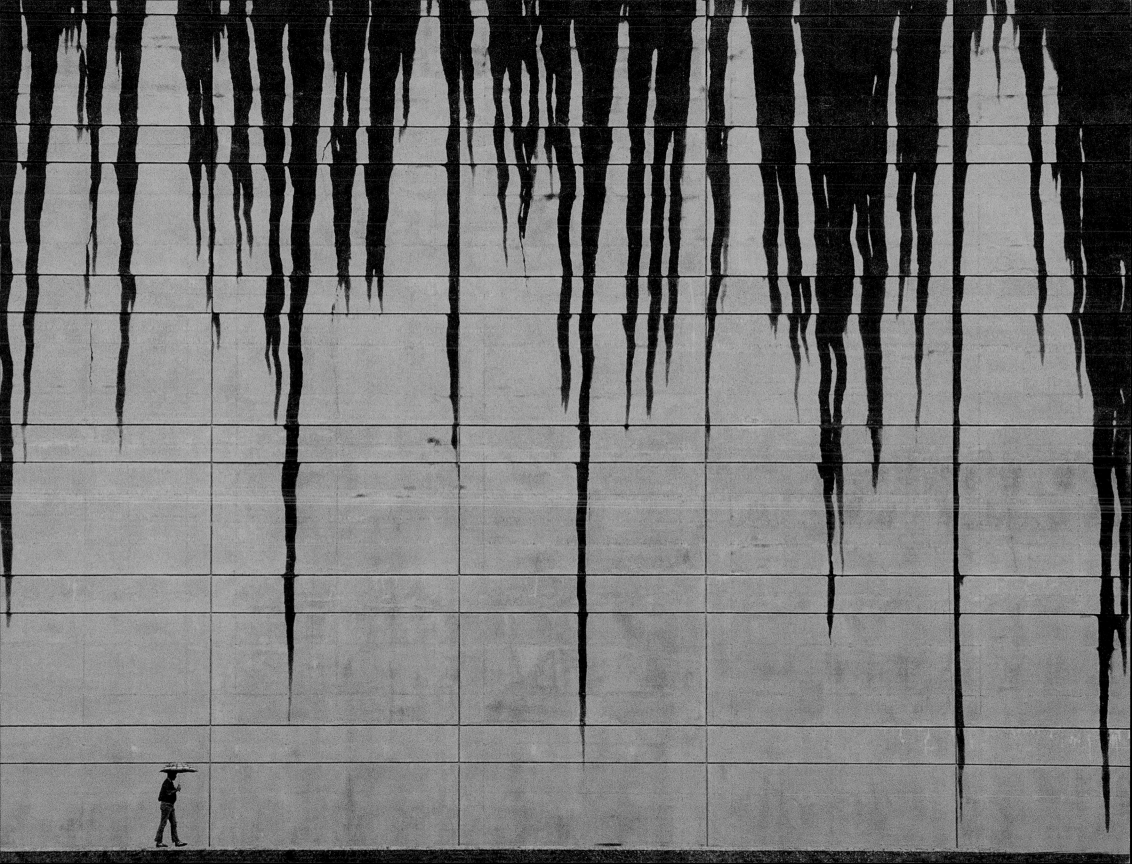

80 Pentagon

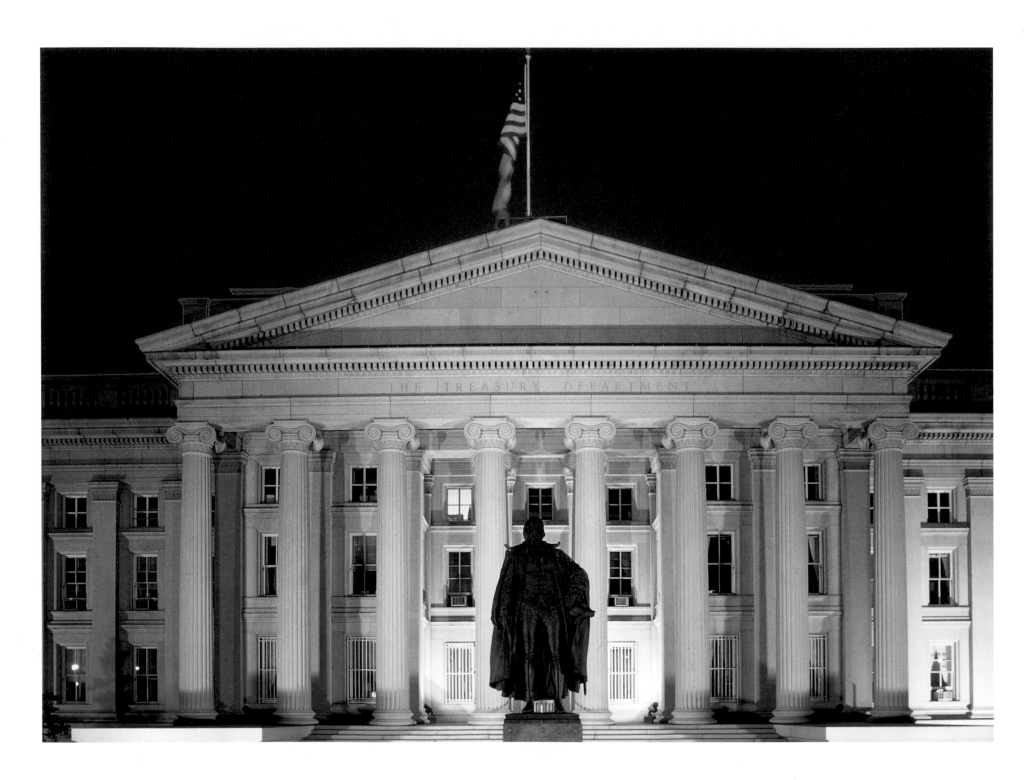

82 Treasury Department

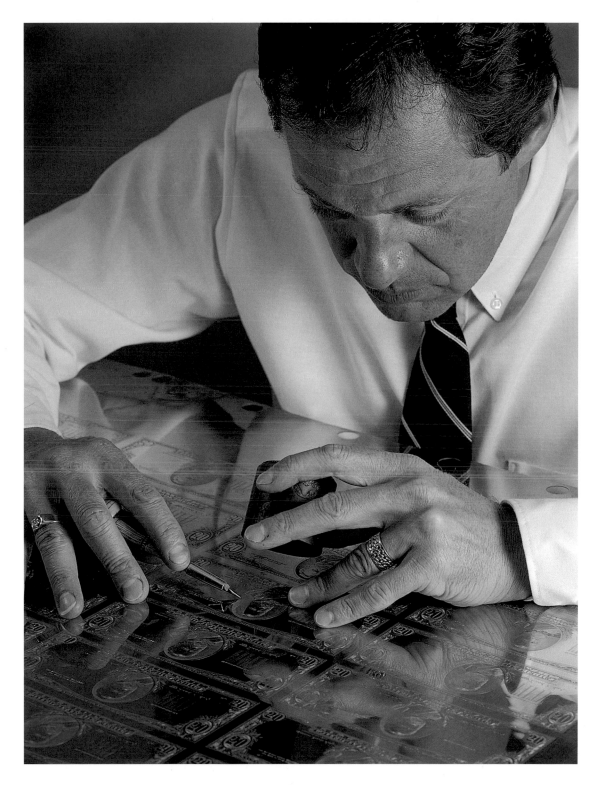

83 Bureau of Engraving & Printing

NATURE & PARKS

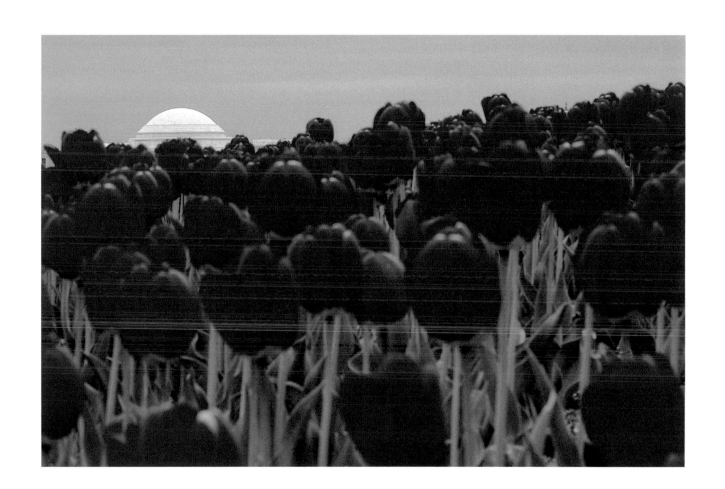

The Federal Government and the famous monuments and museums bring Washington its notoriety, but to the city's residents the quality of life owes much to the presence of nature.

The C & O canal and its towpath, which parallels the Potomac River for 186 miles, has always been my favorite place to think, relax and refresh the soul. It is a soothing environment for boating, jogging, biking, walking, and fellowship (87,88,89).

As it glides by the city, the calm, wide Potomac offers boating, canoeing, sail fishing, and sculling (90,91). Not far away, a boat basin on the Virginia side of the river gives the area a touch of the atmosphere of a small Maine coastal village (92). An aerial view of the spot where the Anacostia River converges with the Potomac River and the Washington Channel, at Fort McNair (home of the Army War College) and Hains Point, is a great vantage point on the city (93). The Anacostia has been, for decades, the most ignored significant natural resource of the city. It is finally getting the attention it deserves, as a major cleanup effort, spearheaded by volunteers, is having an impact.

Just a few miles to the northwest, the generally quiet Potomac takes on a dramatic, even threatening, energy at Great Falls, where it crashes down rocky gorges and is completely impassable (94,95). The falls are impressive at any time of day and in any light. The views from both banks of the river are quite dissimilar; these two views are from the Virginia side.

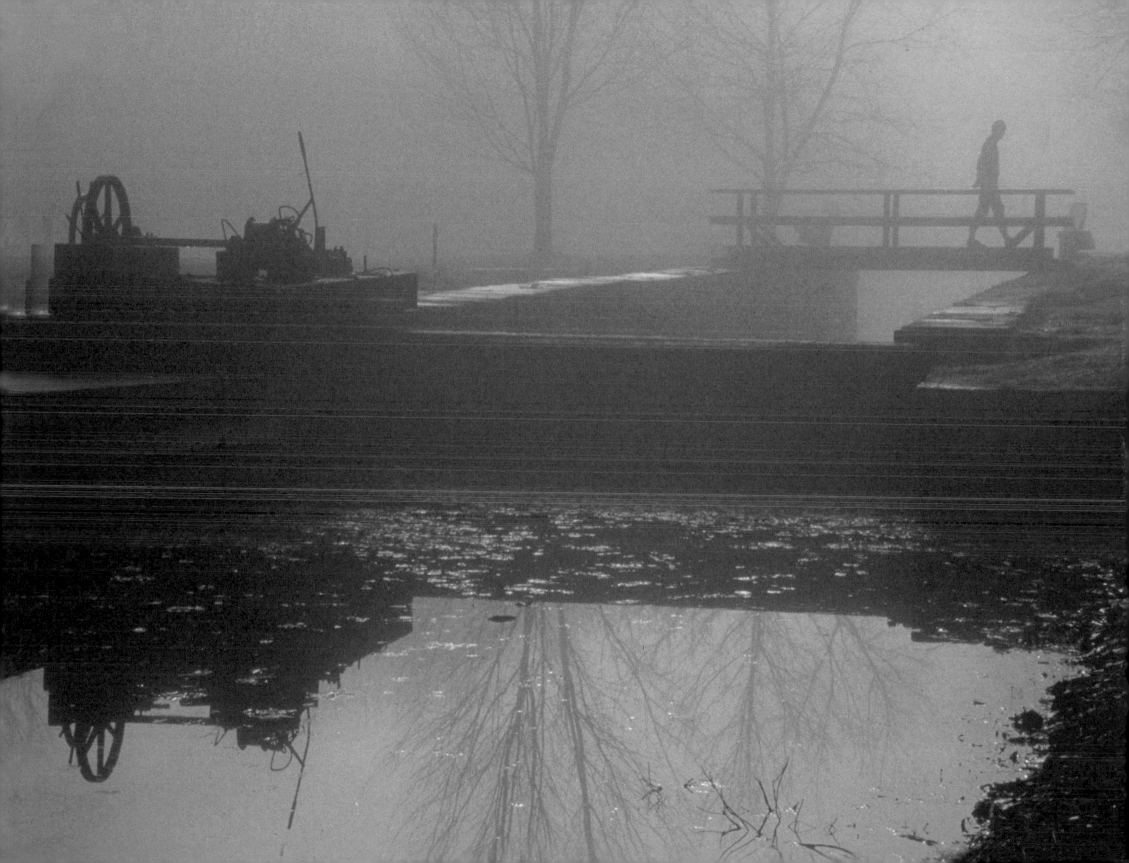

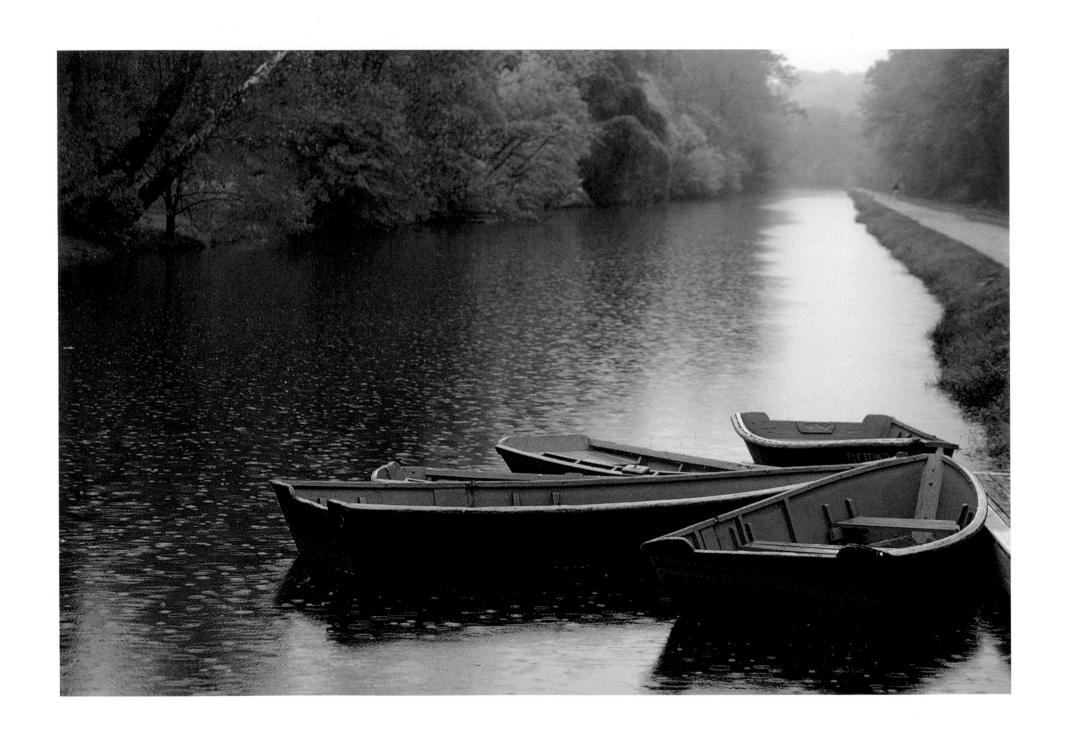

88 C & O Canal, Fletcher's Boat House [87 C & O Canal Lock #7]

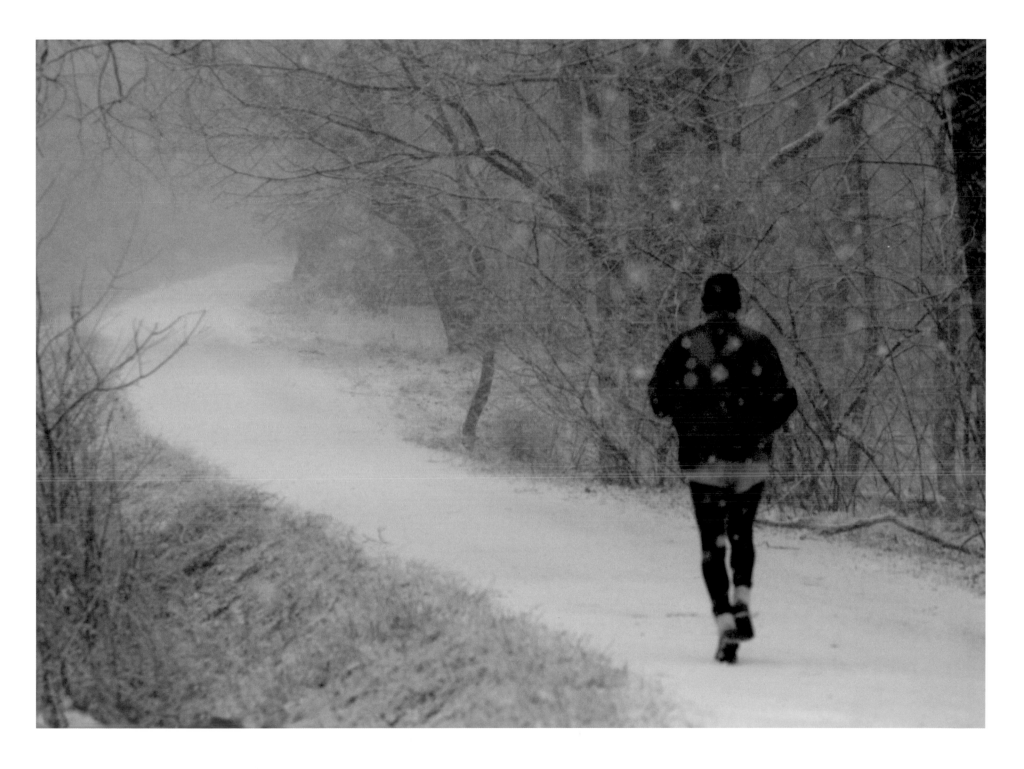

89 C & O Canal Jogger [90 Crew on the Potomac; 91 Canoeing toward Kennedy Center]

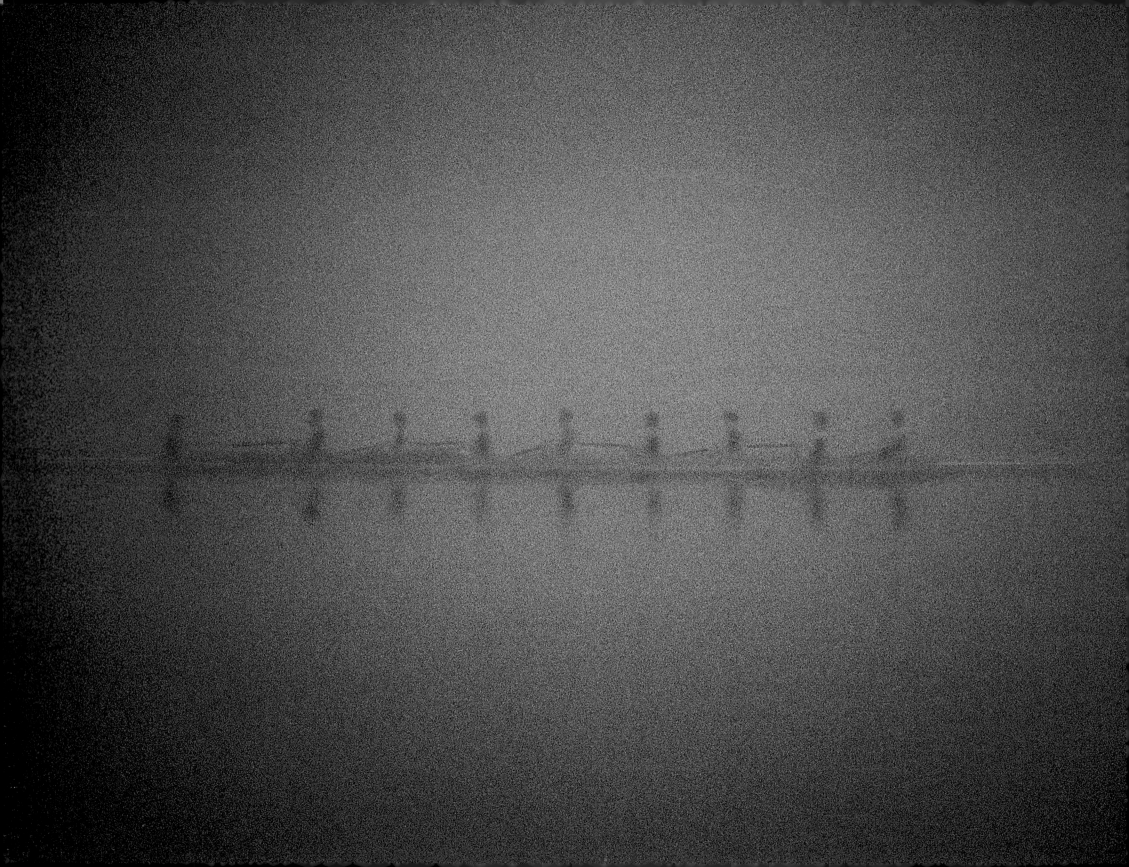

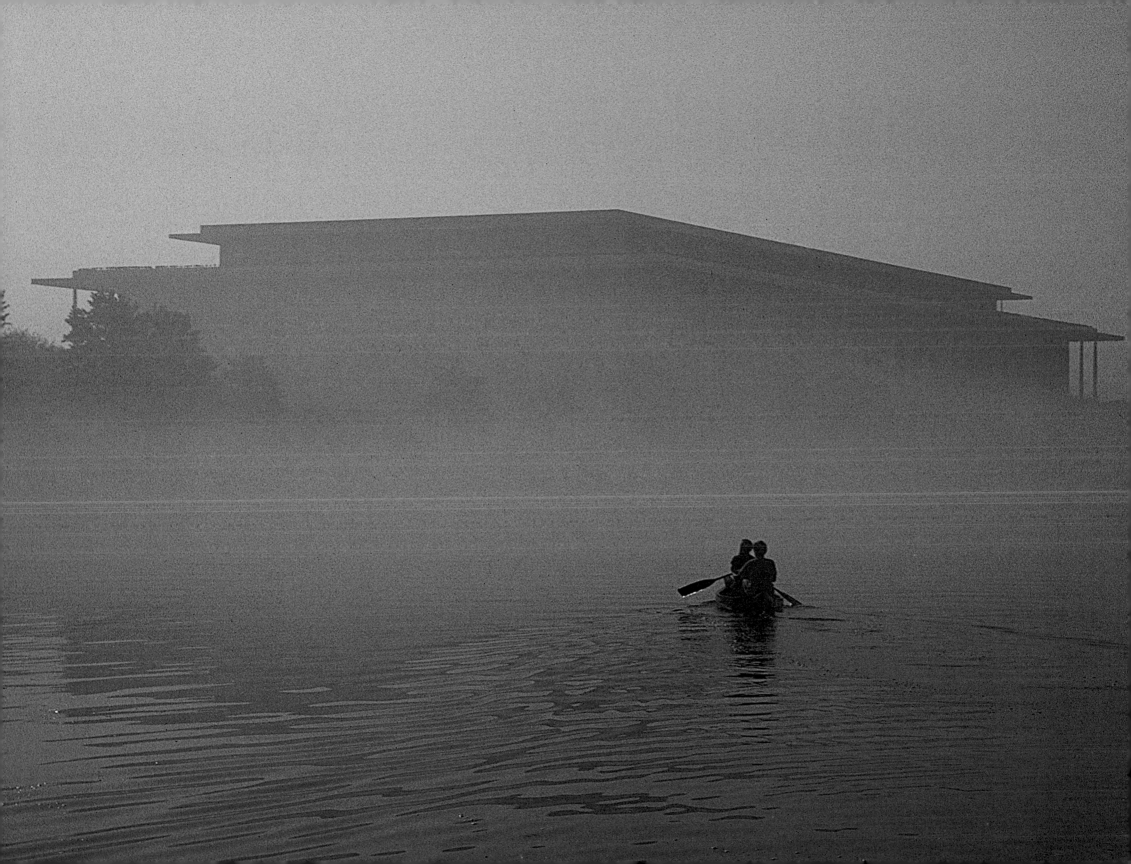

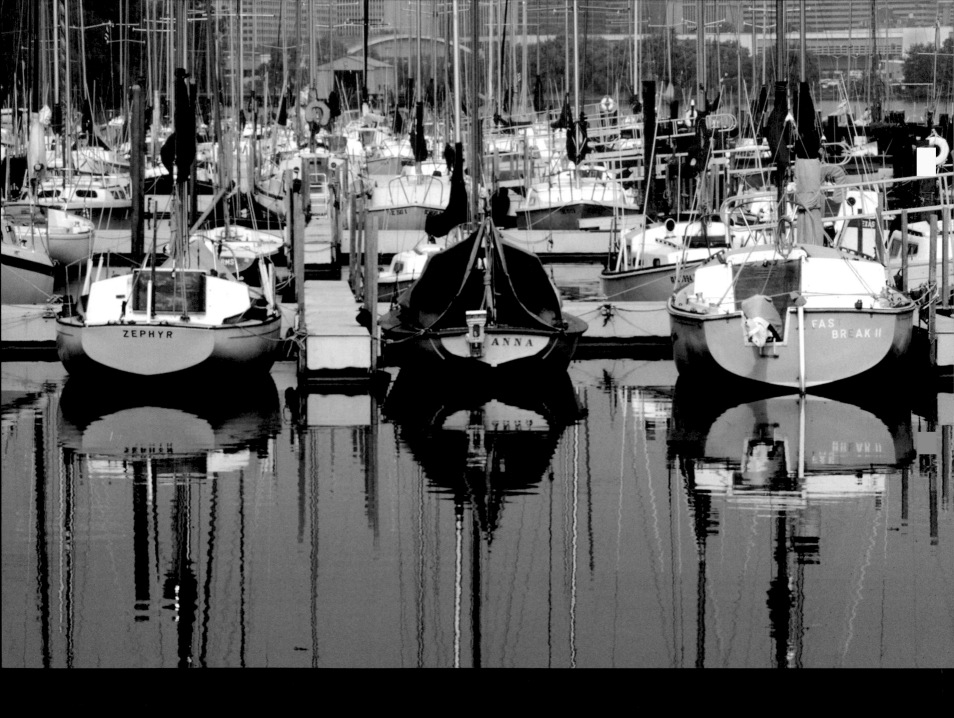

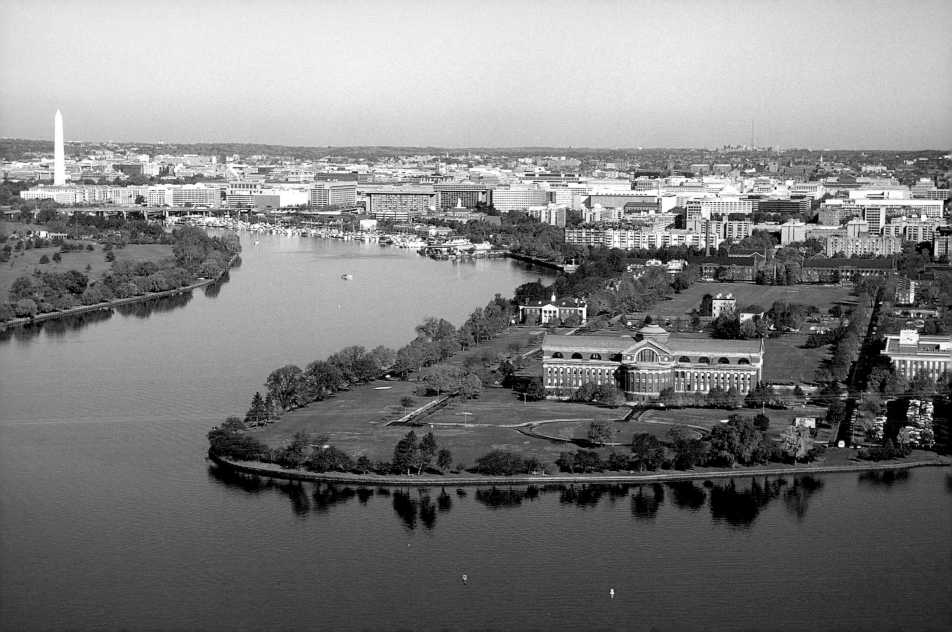

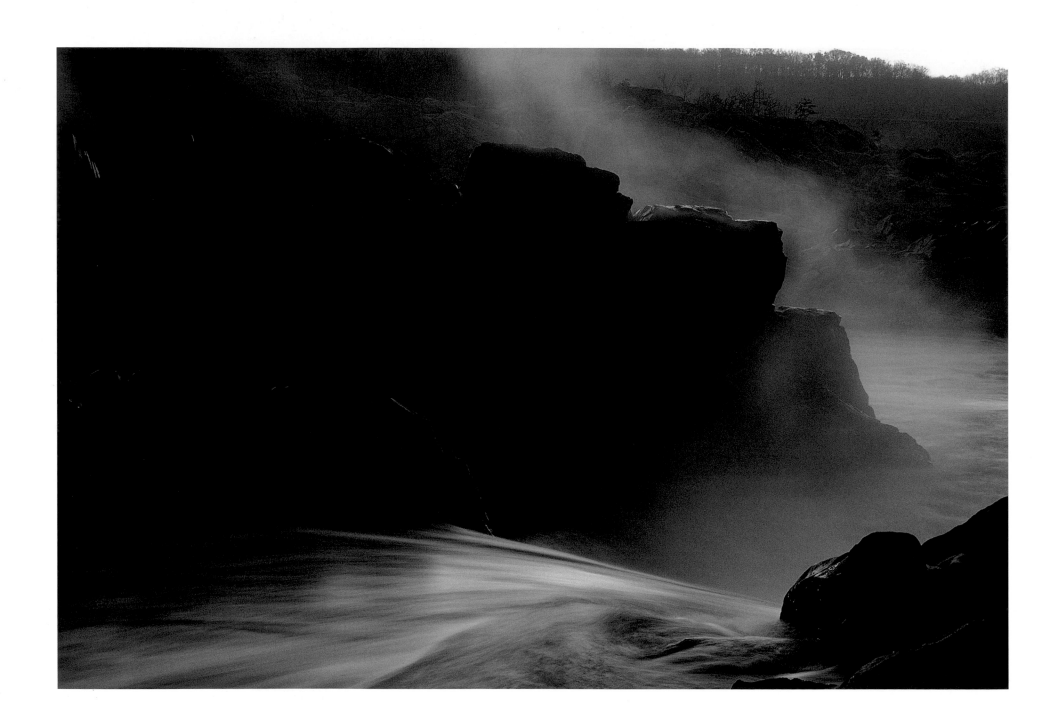

94 [95] Great Falls

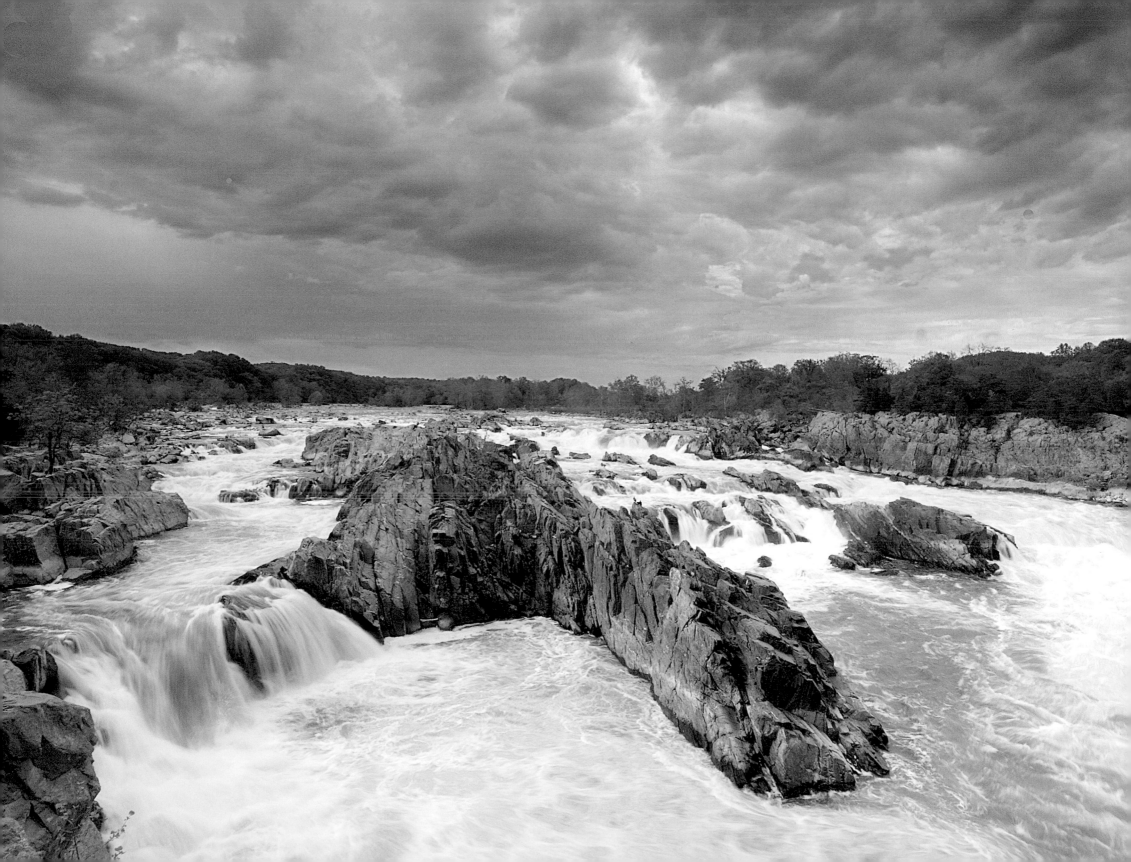

The city contains a multitude of parks, with a wide variety of flavors.

The National Arboretum, in northeast D.C., contains a vast array of flora, including a notable collection of bonsai trees (98). It's also home to an improbable cluster of columns which were extracted from the Capitol when a façade was moved (97). Just east of the Arboretum is Kenilworth Aquatic Gardens, where super-sized lily pads grow in abundance (99).

Meridian Hill Park has a fabulous fountain (when the water is running), which is an irresistible place for kids to cool off in the summer (100).

One of the most prominent features of the city is Rock Creek Park, a quiet, rustic, vast park that shoots through the center of the diamond-shaped District. It's a great place for kids to romp around (101). I used to bike to work through Rock Creek Park. From bustling Connecticut Avenue, I'd coast downhill into the park, pass over a quaint stone bridge (102) and by an old stone grist mill . . . then peddle onto a trail winding alongside the creek and through the back side of the National Zoo, whose most famous residents are pandas (103). Then I'd wind down by the often flower-lined trail near the Potomac River. How many cities offer that kind of commute?

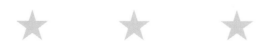

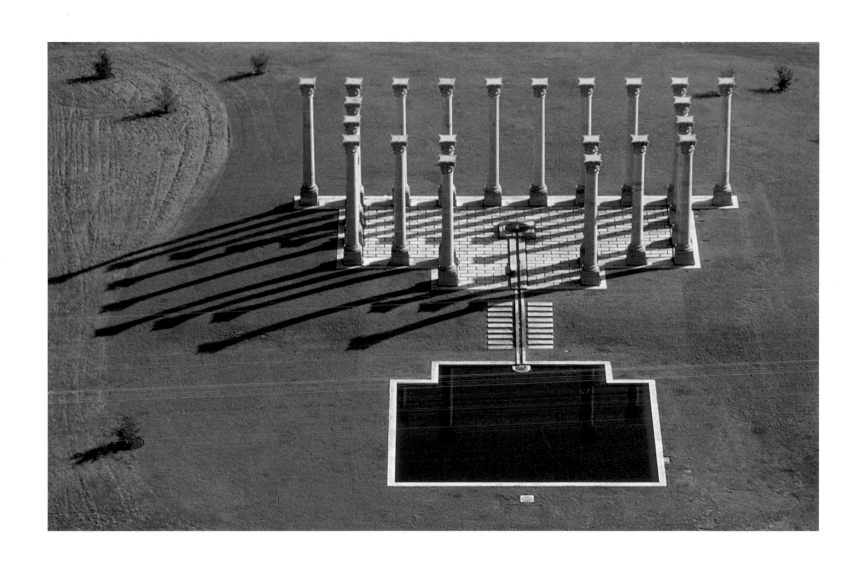

97 National Arboretum, Congressional Pillars

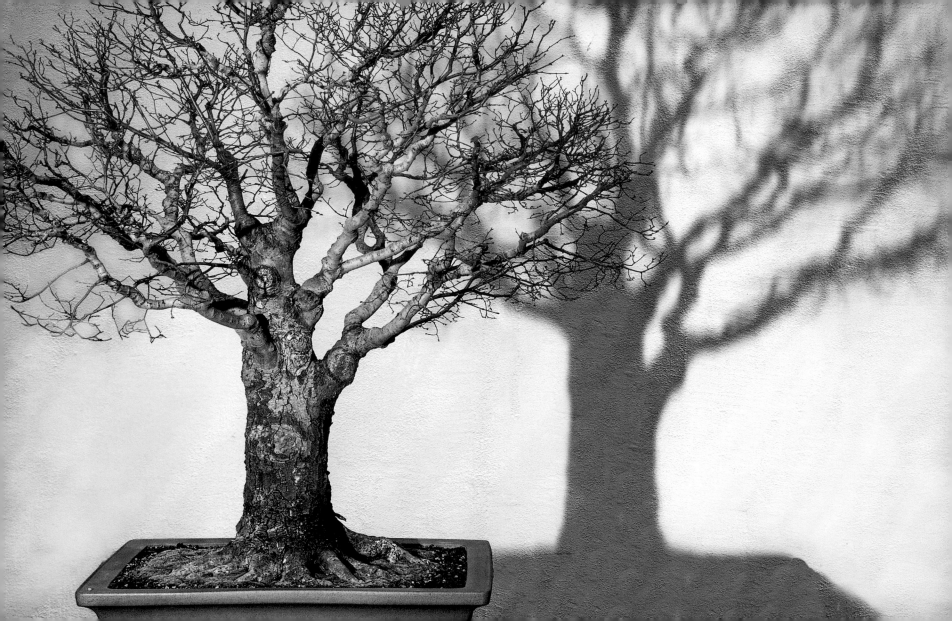

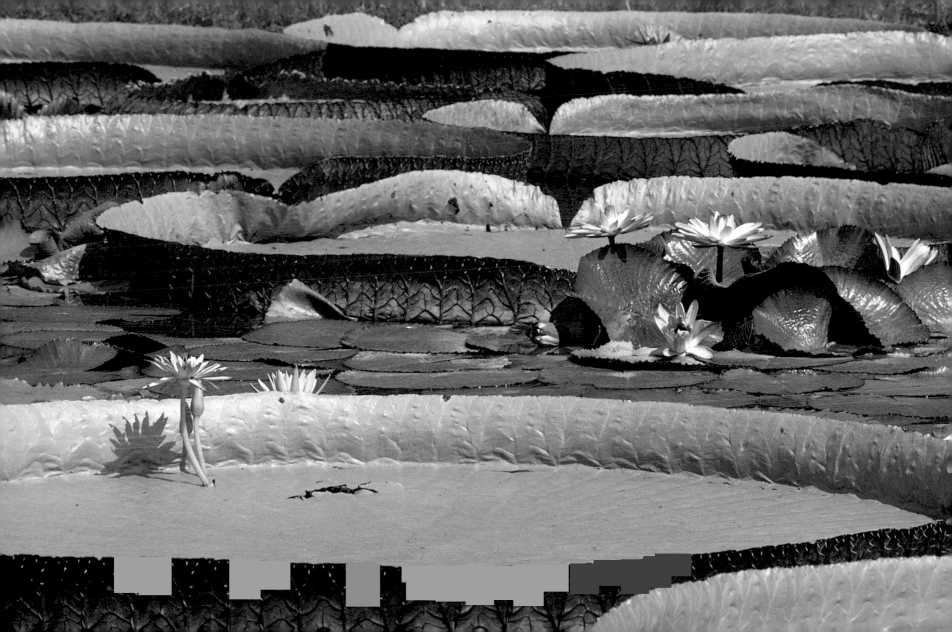

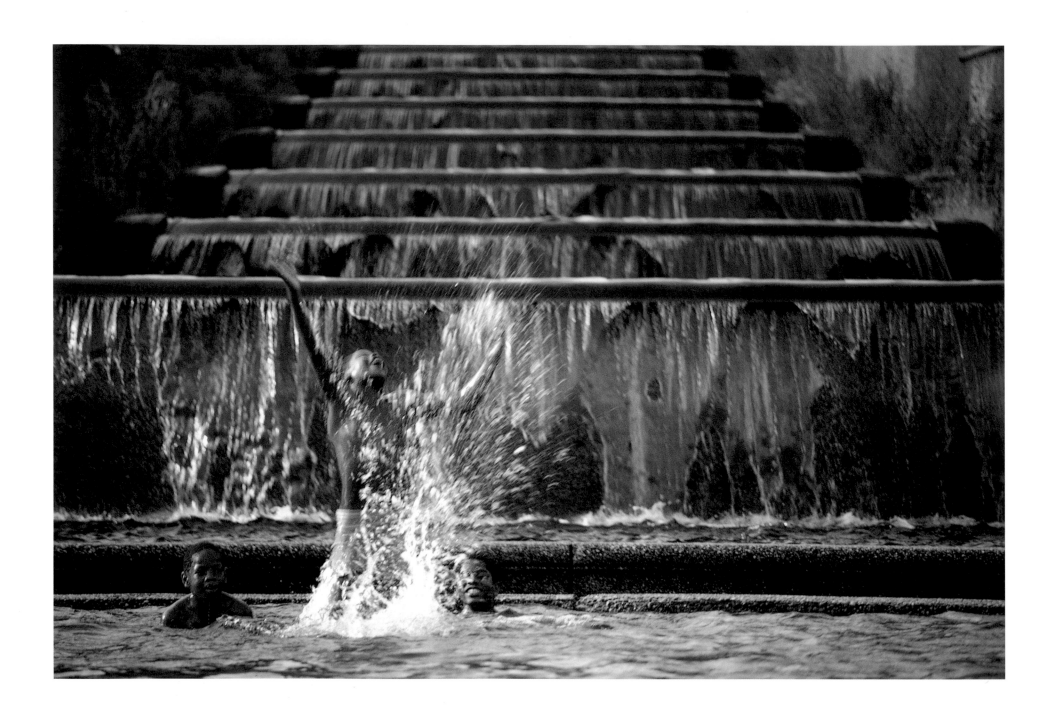

100 Meridian Hill Park

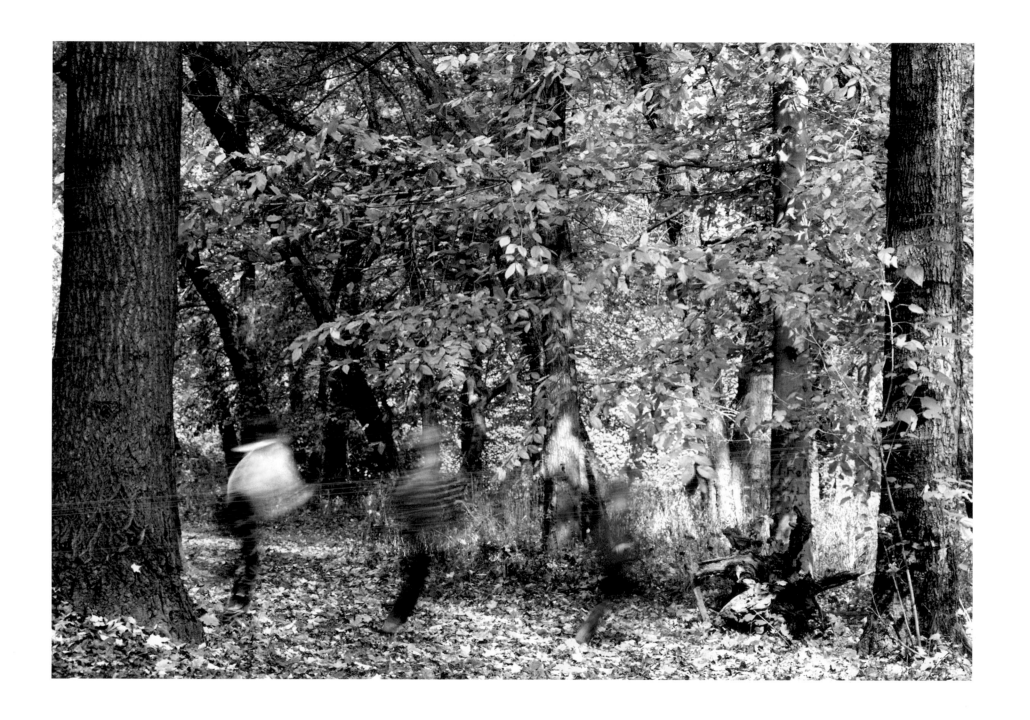

101 Rock Creek Park

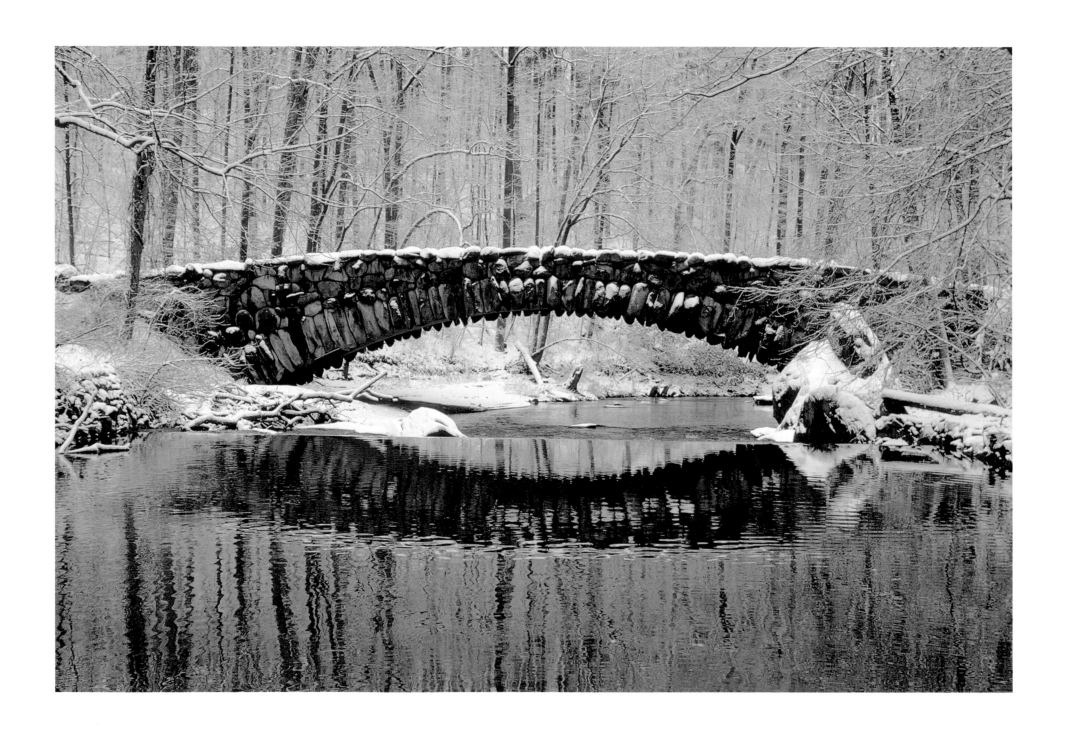

102 Rock Creek Park, Beach Drive Bridge

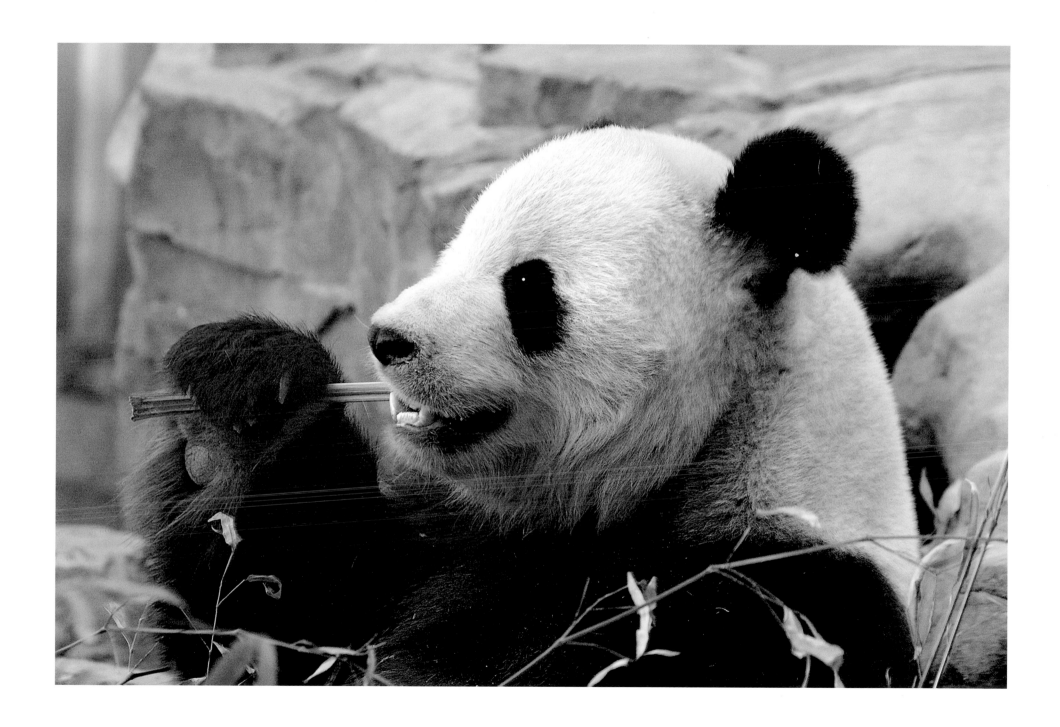

103 National Zoo Panda

ON THE MOVE

The modes for getting around Washington are like any other large American city, but to this photographer they seem to offer distinctive possibilities.

A moving Tourmobile, with its windows removed in summertime, reveals the Lincoln Memorial's pillars in the background (105). In the metrobus yard in Alexandria, Virginia (107), a driver came by and looked down at me lying in the puddle of water that remained after the buses were washed:

"Hey, whataya doin' lying there in the mud?"

"Come down here and look through the lens and you'll see."

He shook his head in disbelief. Non-photographers often can't understand our behavior.

D.C.'s Metro is not just an exceptional means of travel—quiet, clean, fast—it is also an architectural tour de force (108,109). If you're thinking of photographing an escalator from above as I did, I urge you to rely on a strong and trusty assistant since a good shot requires that half your weight lean over the edge.

Union Station always had a grand exterior (111), but it took several renovation efforts before the architects nailed the interior, creating an inspired cathedral to rail travel (110). Flowing out of the station is an intense maze of tracks that glow at sunset (112).

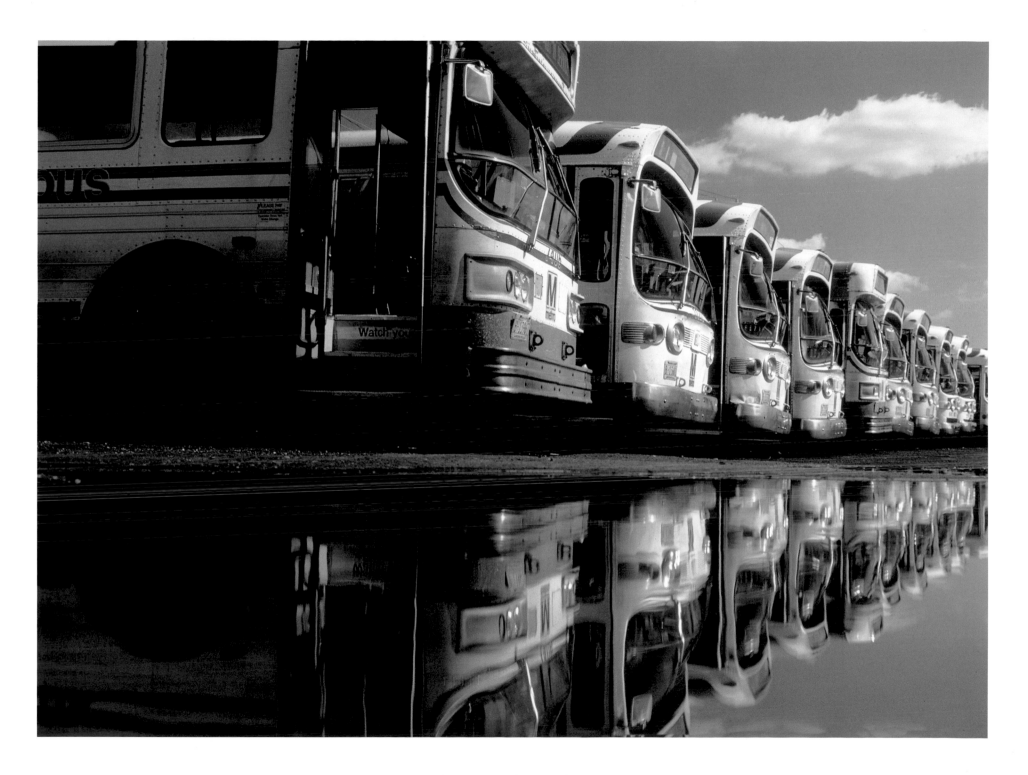

107 Metrobuses, Alexandria, Virginia

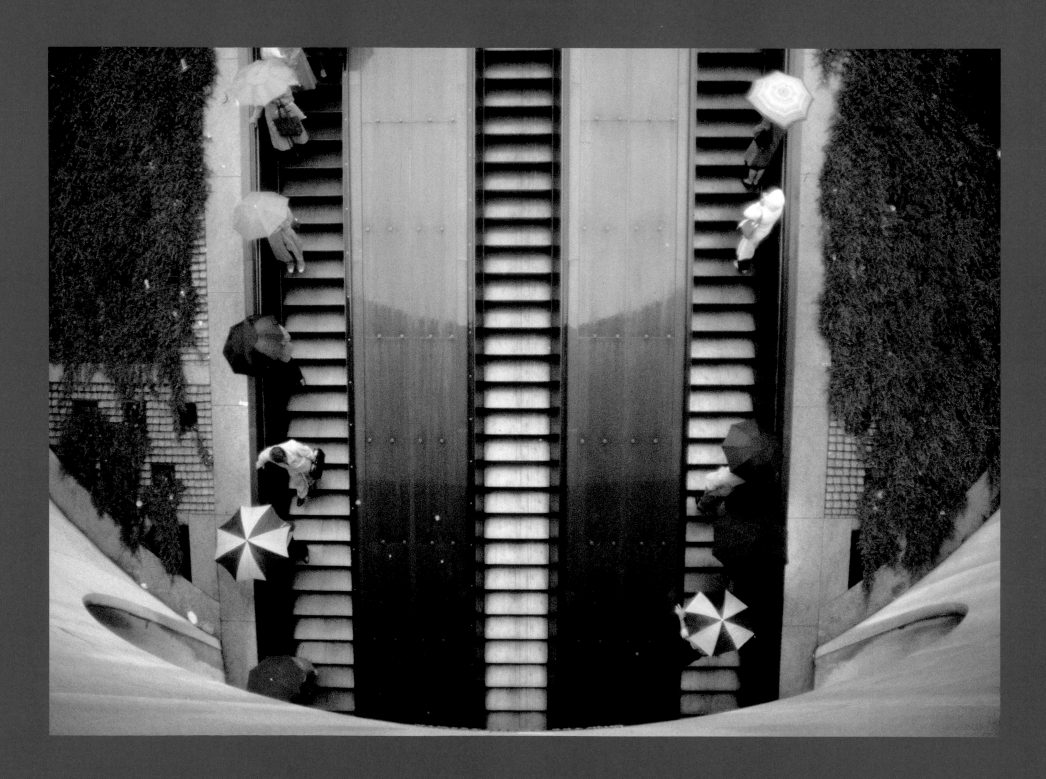

108 Metro Escalator, Dupont Circle

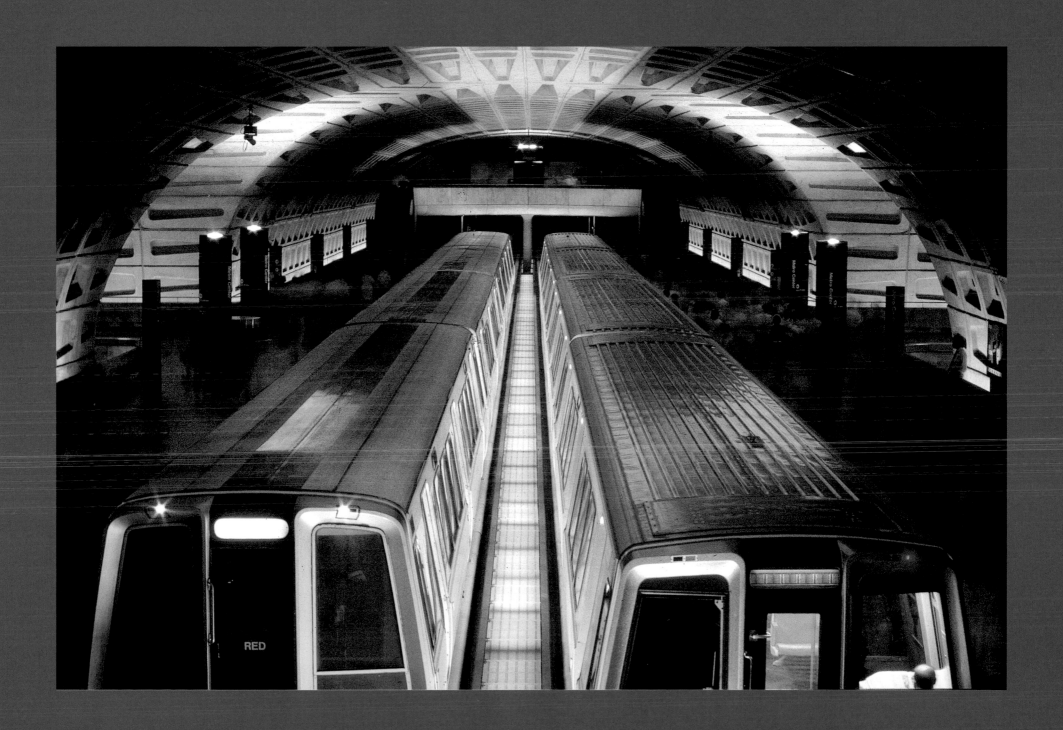

109 Metro Center

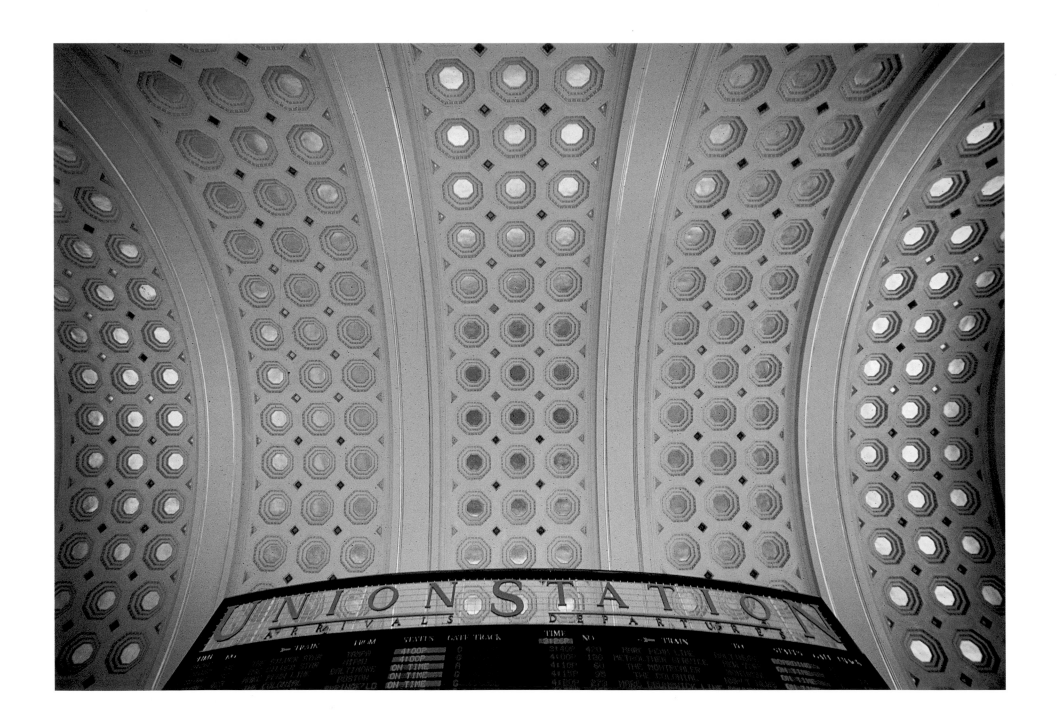

110 Union Station

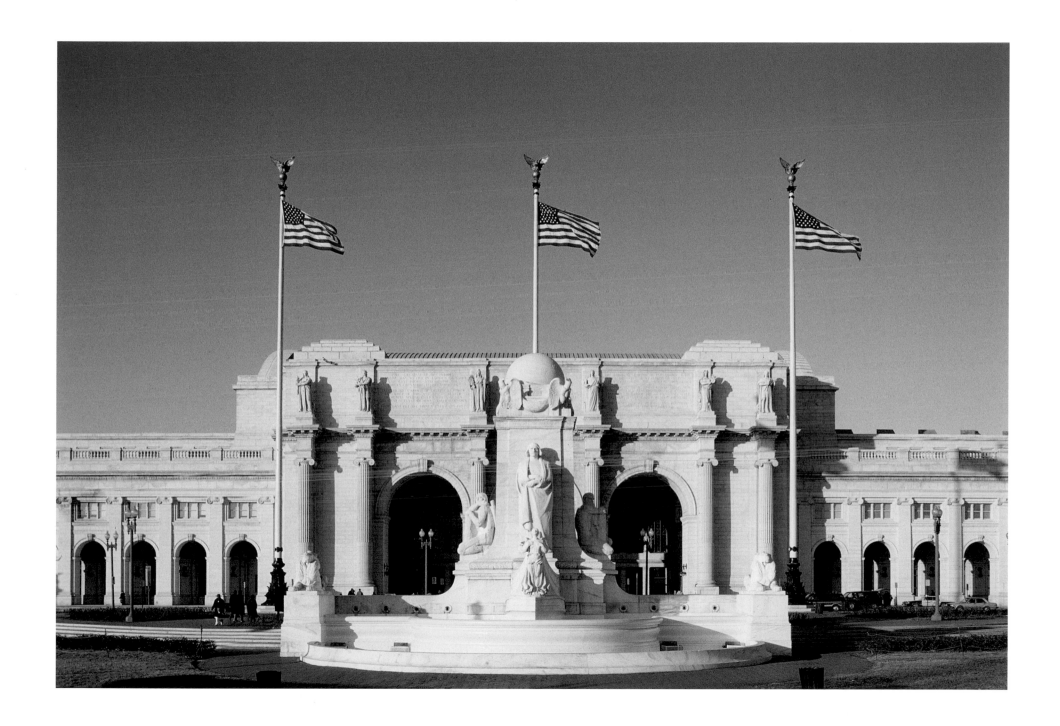

111 Union Station

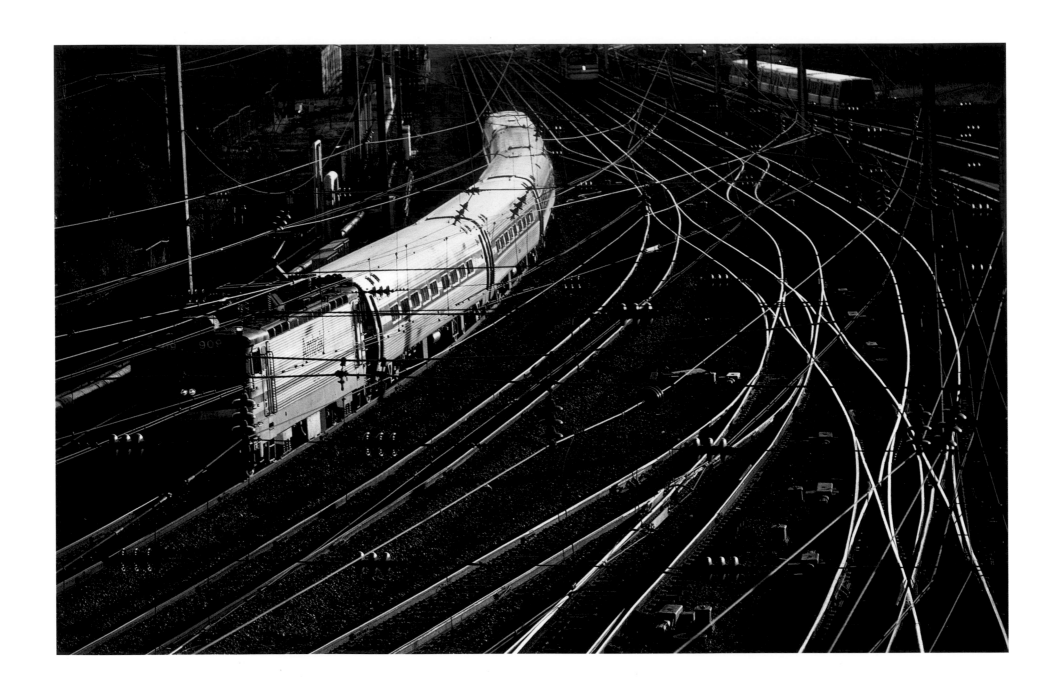

112 Tracks Entering Union Station

My favorite perspective on Reagan National Airport is the adrenaline-triggering view from Gravelly Point, just a few yards from the end of the main runway (114). Dulles is the airport for transcendent architecture (115). In 1962, architect Eero Saarinen created essentially a giant, sweeping ceiling with glass at both ends so extensions could easily be added in the future . . . and the future has already arrived.

Over the quarter century I've spent in D.C., virtually everything has gotten better, with one notable exception: the traffic seems to get worse every year. The beltway is the worst of all, bumper-to-bumper many hours every day. But I-395 adjacent to L'Enfant Plaza can also be dreadful (116), ditto Wisconsin Avenue and M Street in the heart of beautiful Georgetown on any warm weekend day (117).

My two personal favorite modes of getting around are bicycle and feet. Washington isn't particularly a cycler's town, notwithstanding the many wonderful places to bike, one of which is Hains Point, where the cyclists racing here virtually had the road to themselves (118). The walkers on the Mall's dirt pathway are enjoying a morning commute to the office (119).

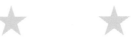

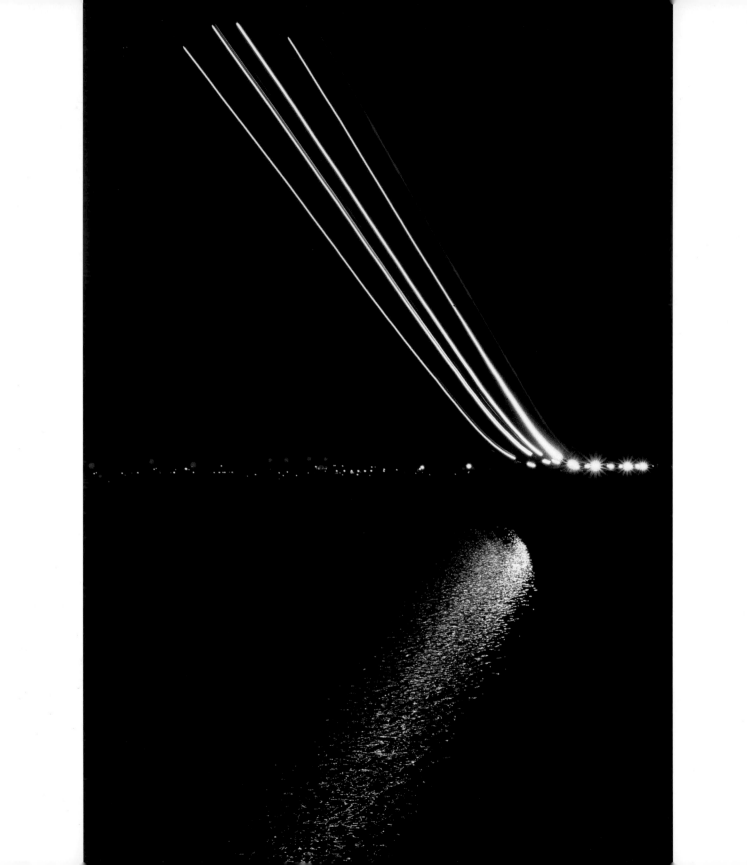

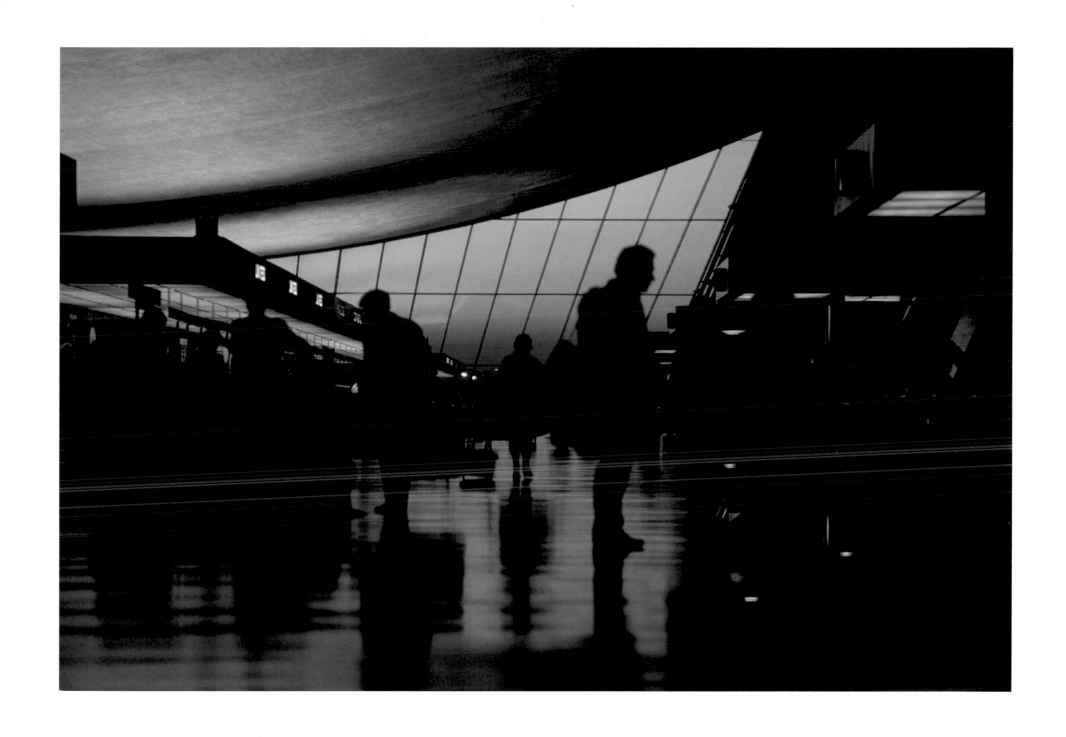

115 Dulles Airport [114 Reagan National Airport]

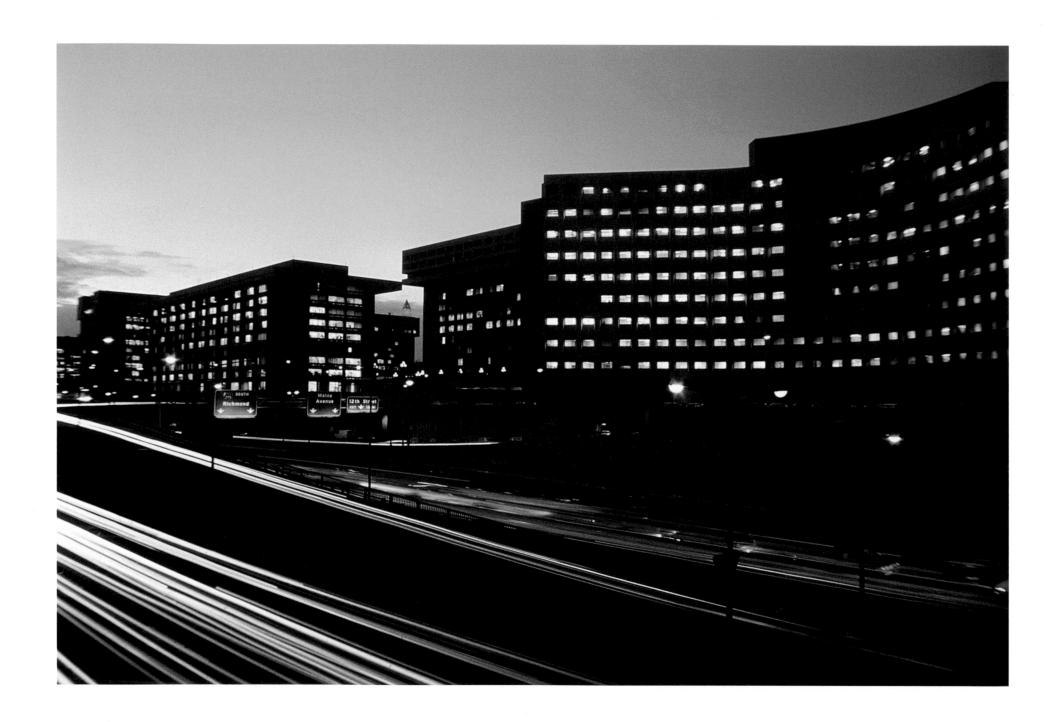

116 I-395 and L'Enfant Plaza

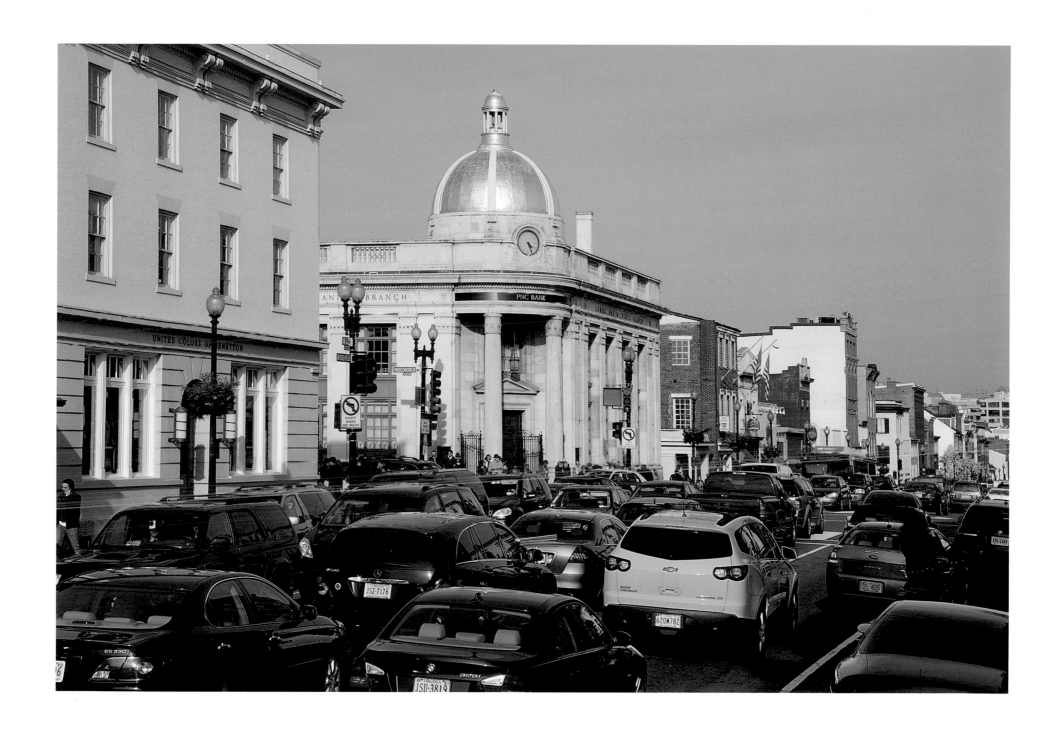

117 Georgetown, Wisconsin Ave. & M Street

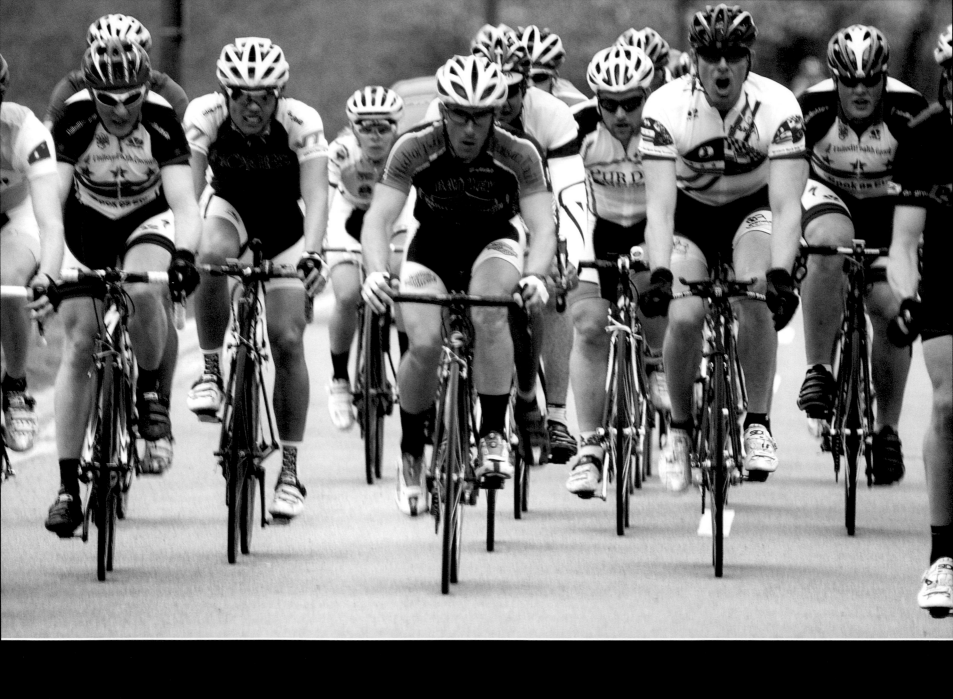

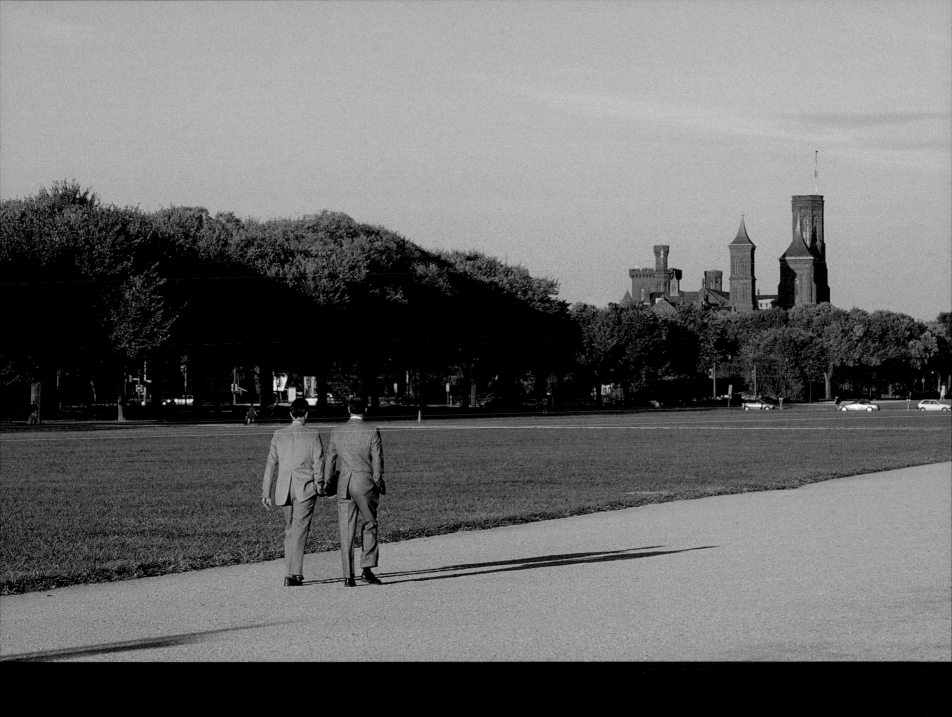

119 Businessmen on Mall

AROUND THE TOWN

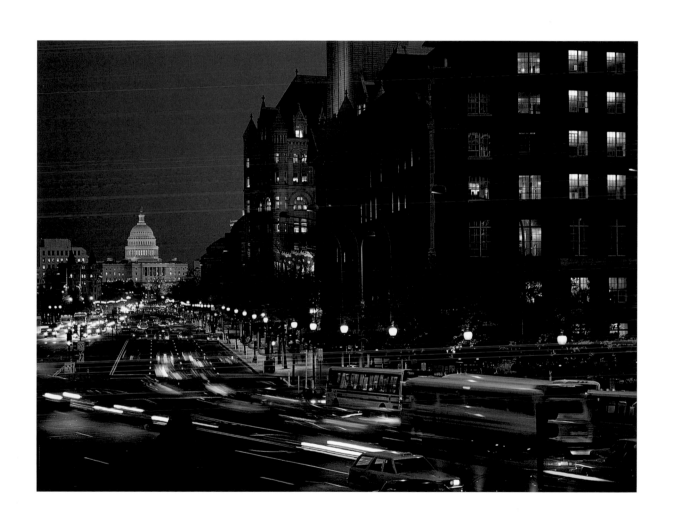

And what of subjects that are not part of the Federal City or the memorial city, not part of the Mall or the waterways and parks? What of the city's neighborhoods, its houses of worship and meeting places, its sports arenas and the many wonderful sights away from the heavily-trod pathways? In this closing chapter, I offer an array of this and that from here and there.

D.C.'s Convention Center is so vast I wonder how many conventions it can accommodate simultaneously . . . but on the Sunday when I photographed it, it was as quiet as a church on Monday (123).

Hundreds of blocks of the city neighborhoods are filled with colorful, handsome brownstones, like no other American city I know (124,125). My favorite neighborhood to walk around is also the most historic: Old Town Alexandria (126), which still has an original cobblestone street. A few miles south of there, at Mount Vernon, is the lovingly restored home of our first president (127).

Kennedy Center's Hall of Nations has an impressive array of international flags (128). Chinatown is ever-shrinking as developers expand the commercial footprint of the city, but the arch remains as a focal point of that small neighborhood and restaurant center (129).

The National Building Museum has a jaw-droppingly large open interior space filled with gigantic pillars (130). The Corcoran Gallery, Dumbarton Oaks, the Phillips Collection and Renwick Gallery are all jewels in their own right (131). Each of these museums would stand out in any other city, but in Washington they are overshadowed by their big Smithsonian brethren.

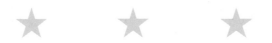

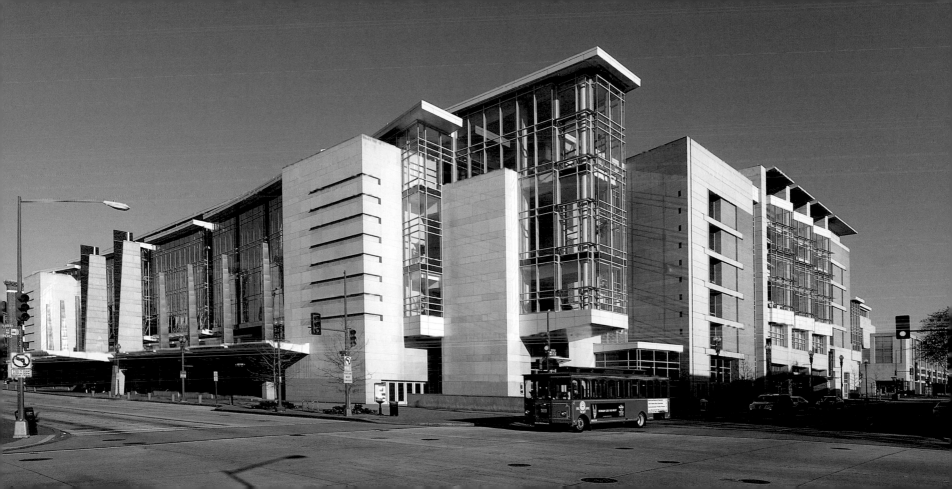

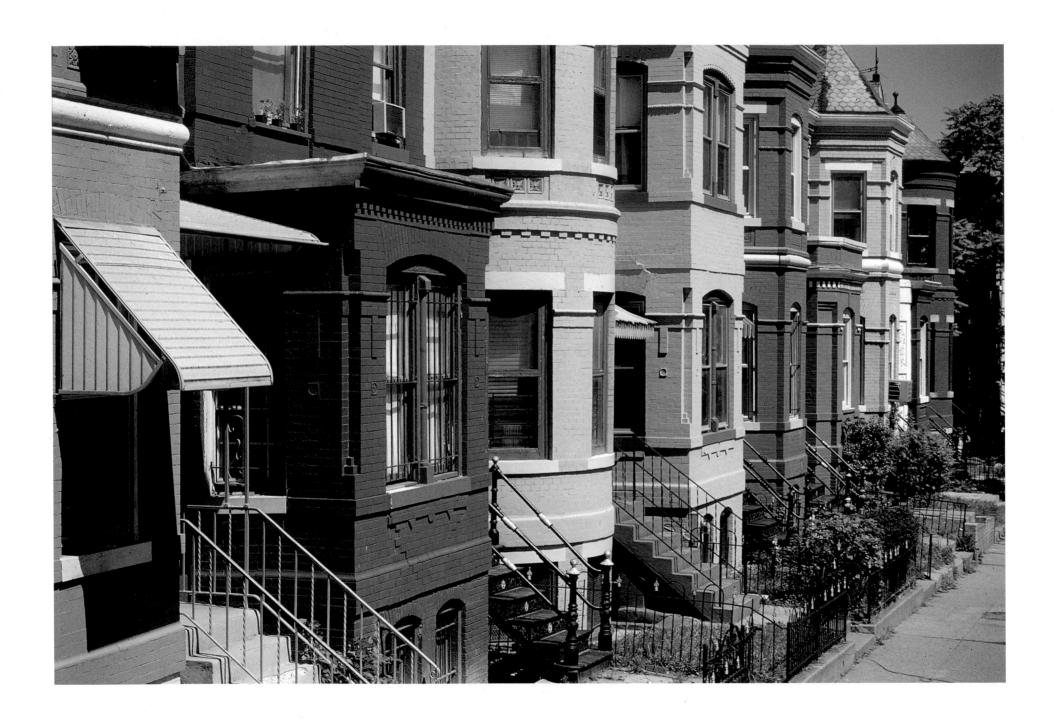

124 6th Street, Northwest

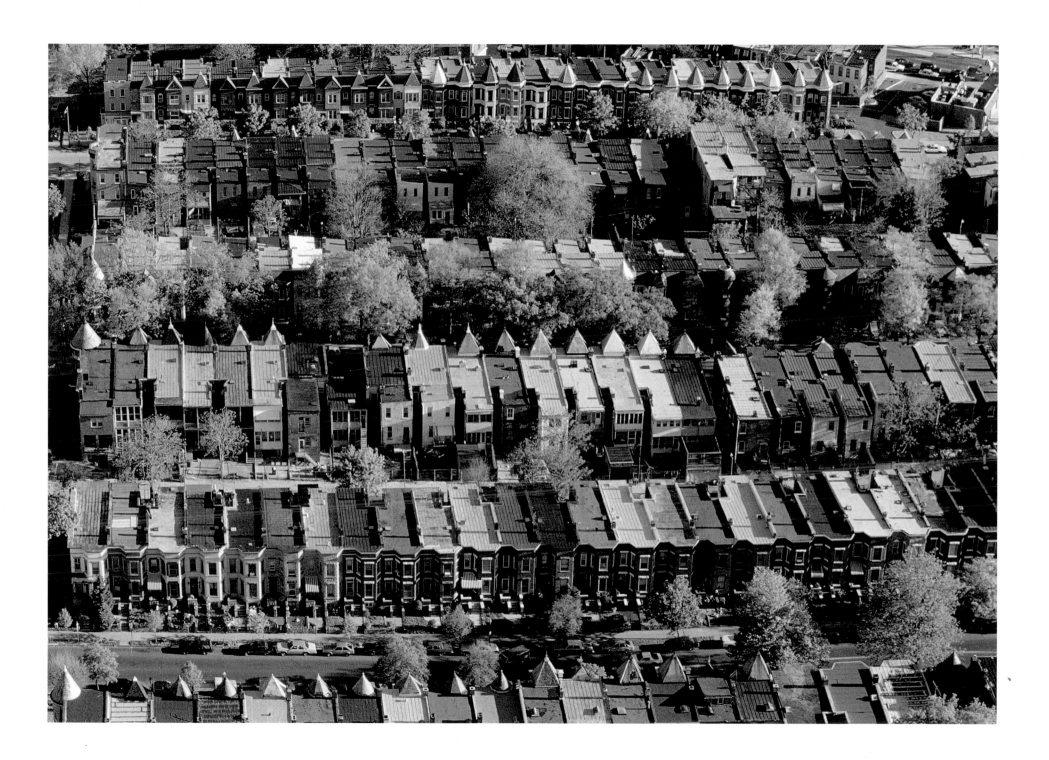

125 Capitol Hill

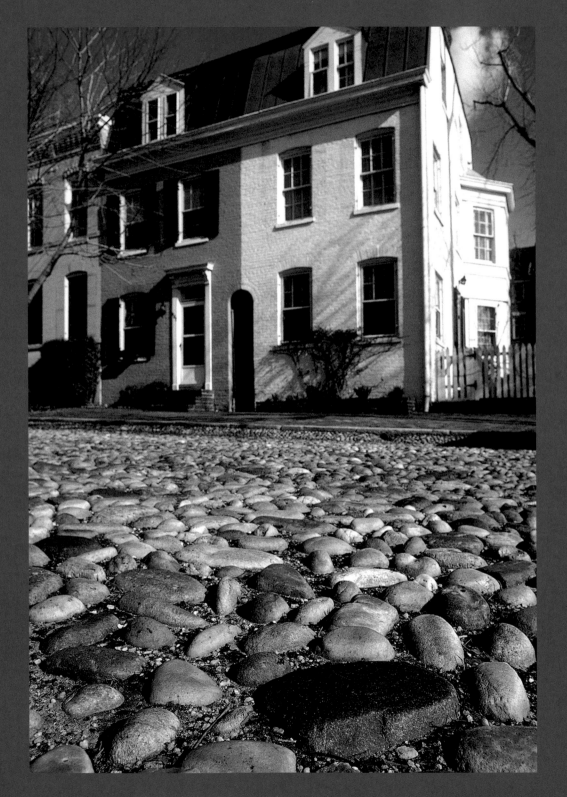

126 Old Town Alexandria, Virginia

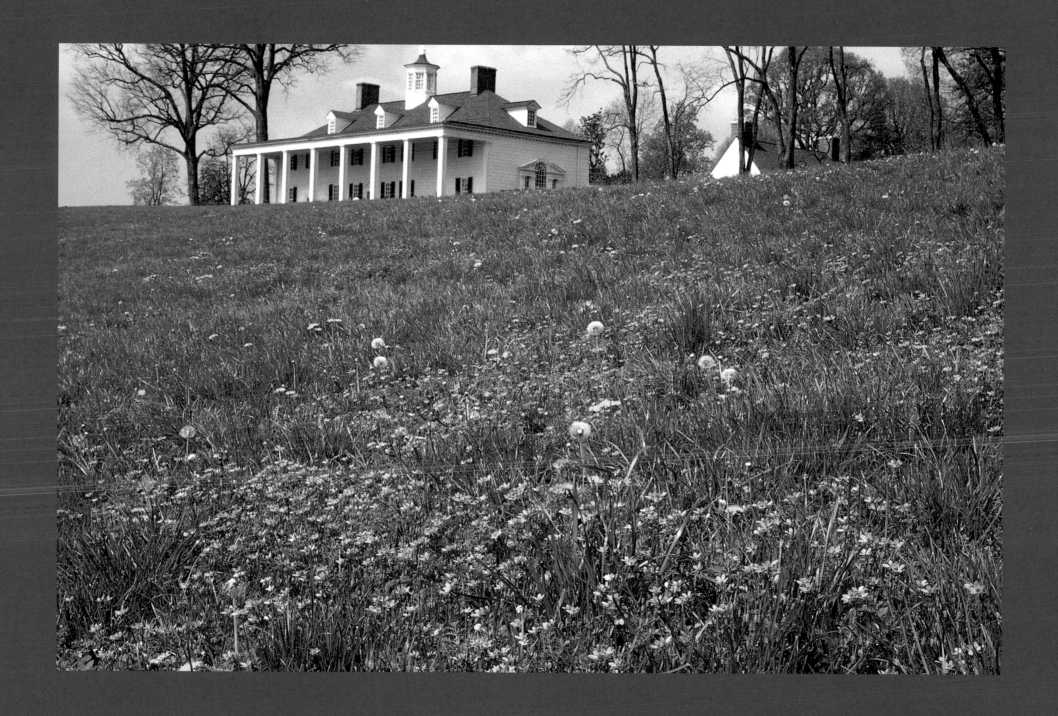

127 Mount Vernon (George Washington's Home)

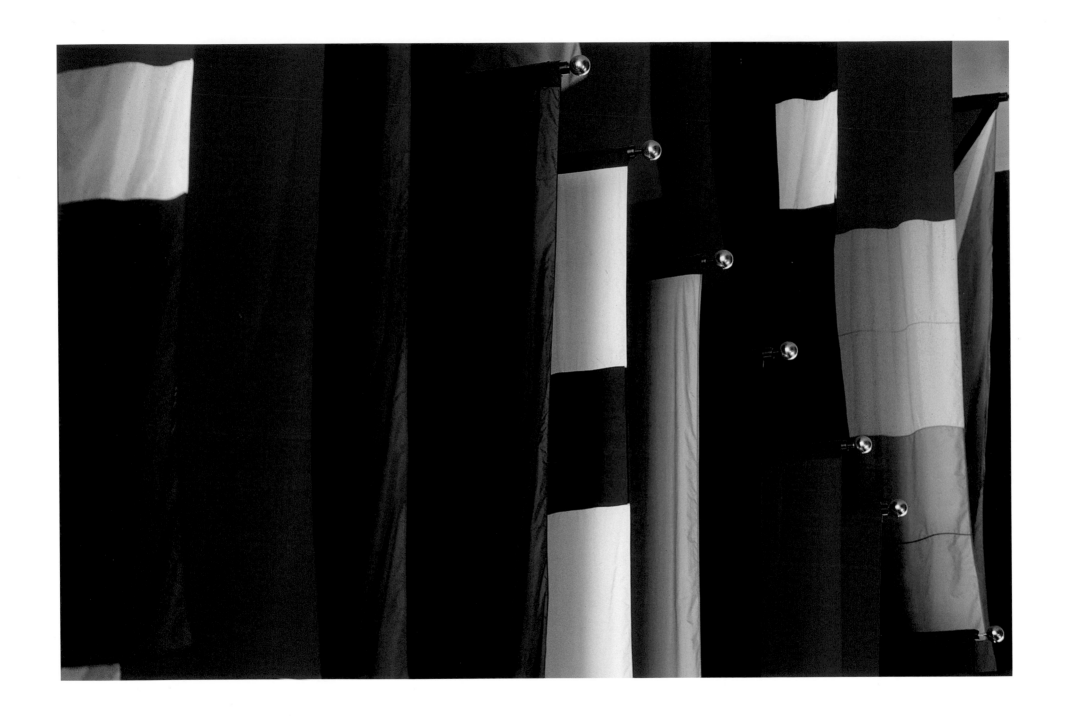

128 Kennedy Center, Hall of Nations Flags

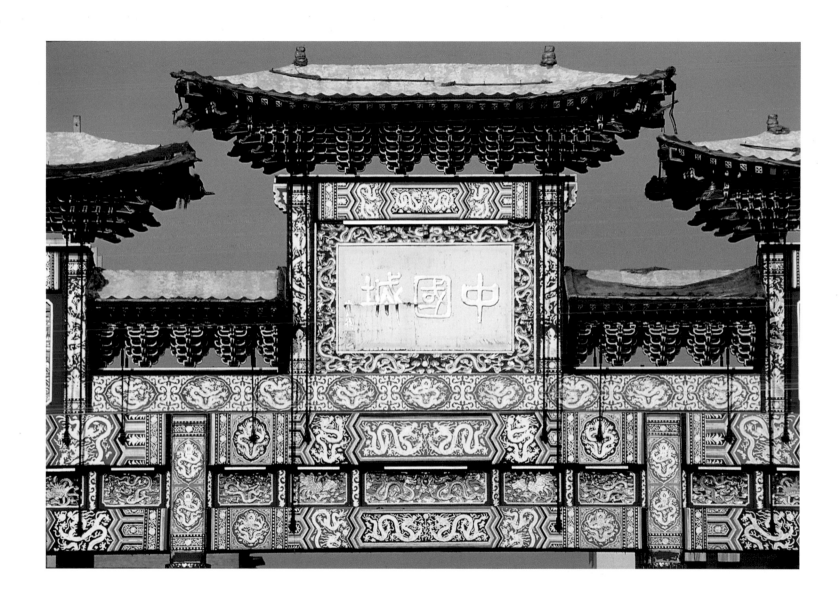

129 Chinatown Arch

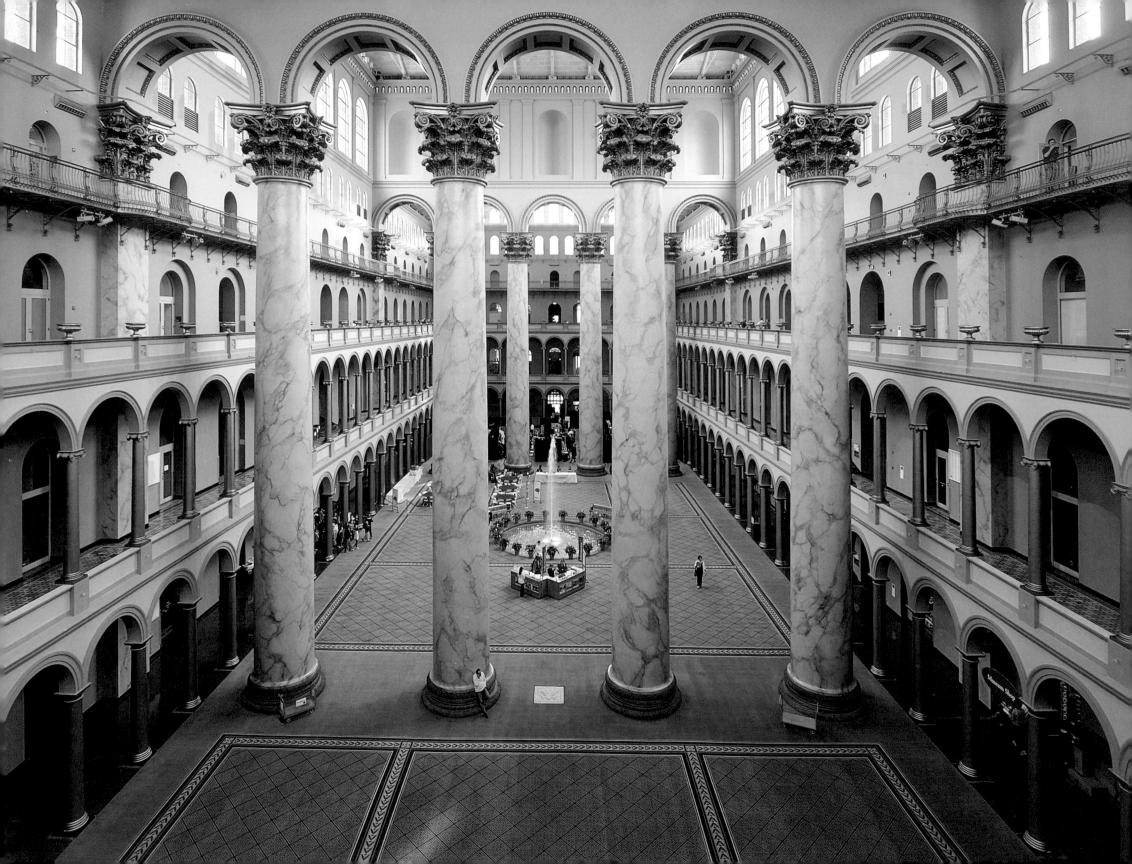

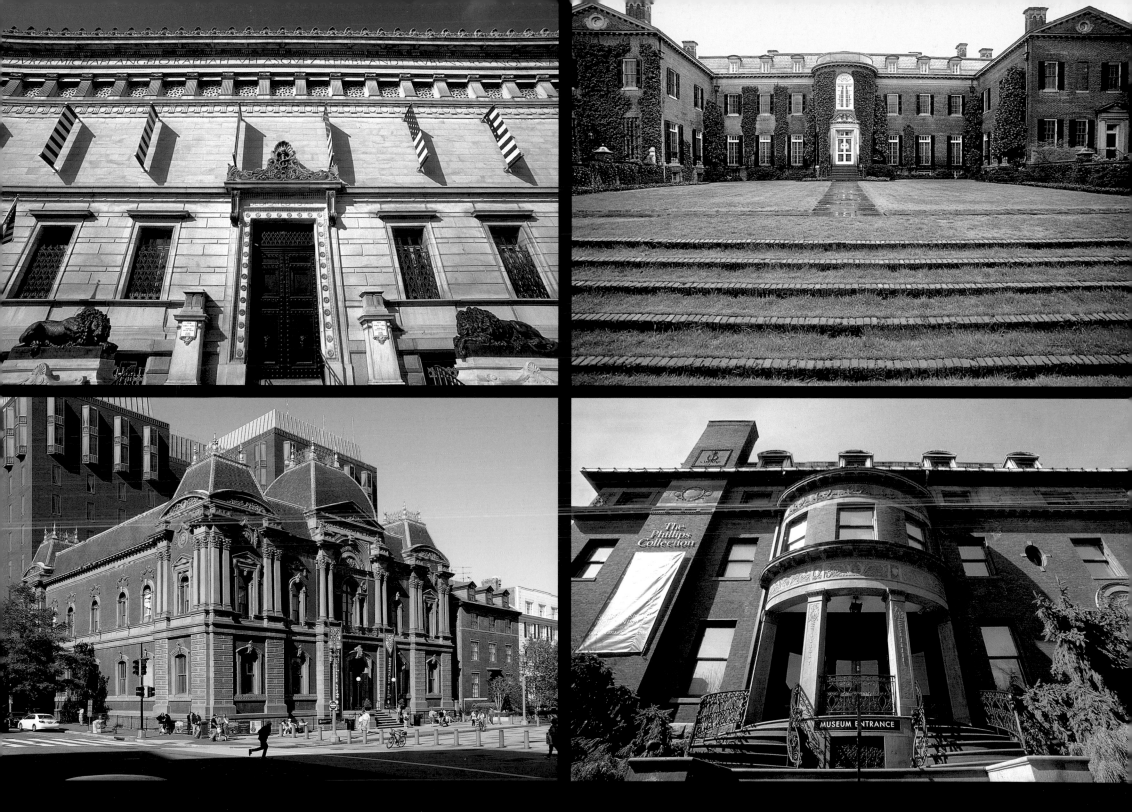

131 (Clockwise from upper left) Corcoran Museum; Dumbarton Oaks; Phillips Collection; Renwick Gallery [130 National Building Museum]

I love to photograph houses of worship, especially in Washington. Our most visible church by far is the Mormon Temple because it rises dramatically above the trees on a small hill overlooking the beltway. The Islamic Mosque and Cultural Center is found along Embassy Row on Massachusetts Avenue, while the tile wall and votive candles (which I merged together) are at St. Matthew's Cathedral in downtown (133). Early morning light spiritually caresses the National Cathedral in northwest D.C. as it streams through its many stained class windows (134). The Franciscan Monastery, in northeast D.C., is a little-visited jewel that combines architectural majesty and pastoral tranquility (135).

Religious worship is a phrase that might extend to Washington sports. After a 35-year hiatus, Major League Baseball finally returned to the city in the form of the Washington Nationals. Negro League star Josh Gibson is honored with a statue at the Nationals Park entrance (136). RFK Stadium, former home to the Redskins, now serves DC United and the world of soccer, among other uses (136).

The city forms an exquisite backdrop for most any activity, so joggers can work out on the steps behind the Lincoln Memorial (137) . . . or for that matter can romp inside the memorials themselves.

As this final chapter ends, I am conscious—perhaps you are, too—of the many notable places that are omitted. Inevitably, some subjects, including some of my favorite places, have been sacrificed on the altar of book length. I hope that what lingers when you finish this book are not my omissions but my affection for this unique city.

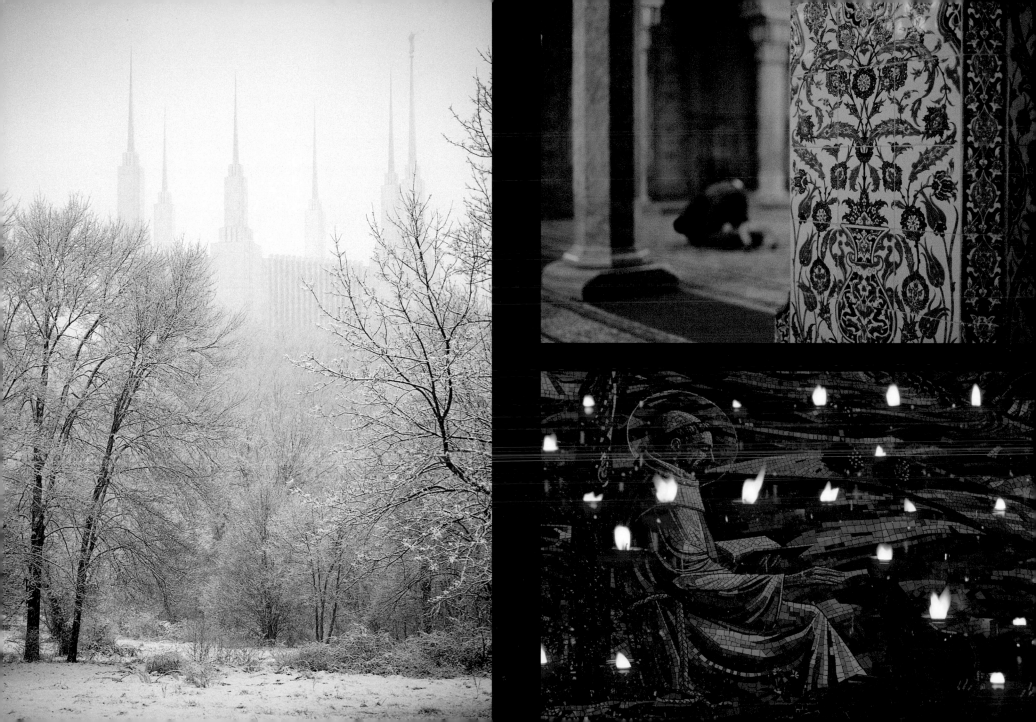

134 National Cathedral [135 Franciscan Monastery]

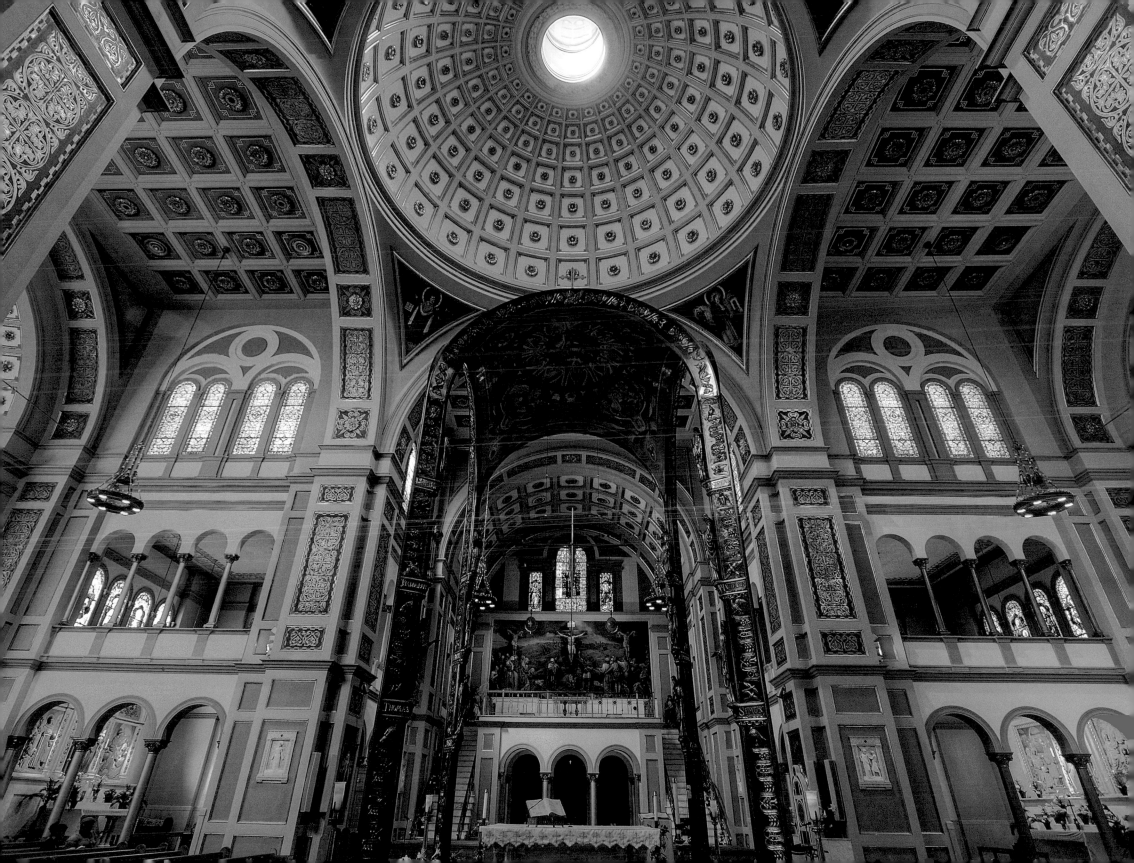

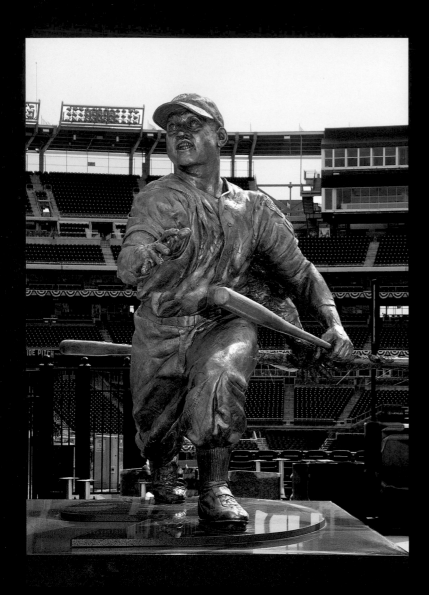

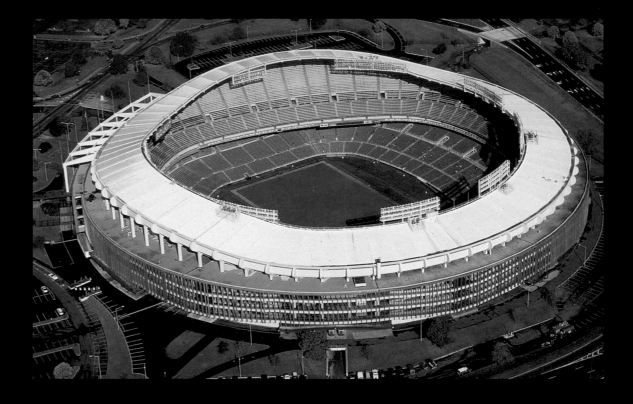

136 Josh Gibson, Nationals Park; RFK Stadium

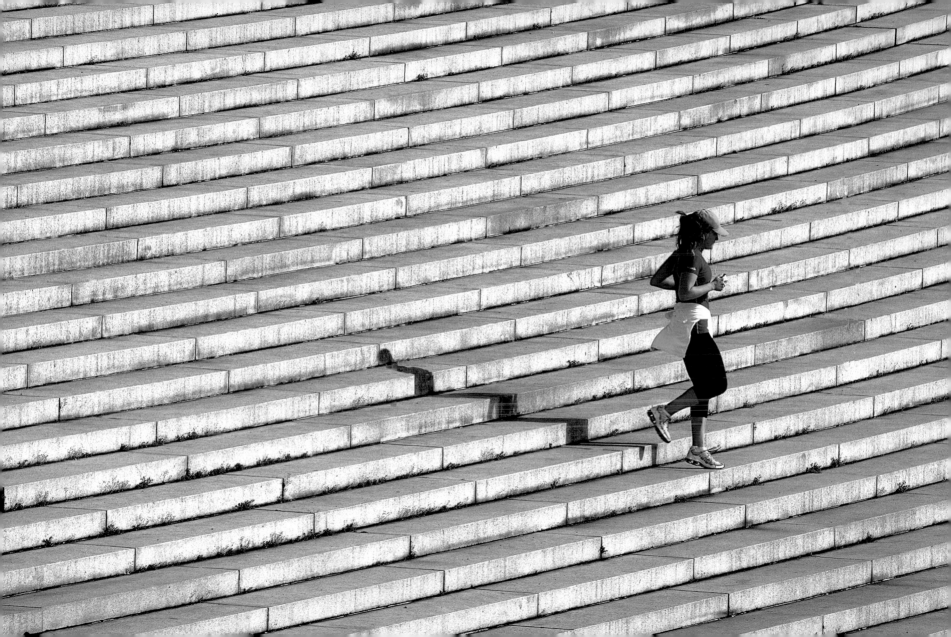

I moved away from Washington some years ago—many factors determine where one lives—but since "home is where the heart is," I still consider Washington my home.

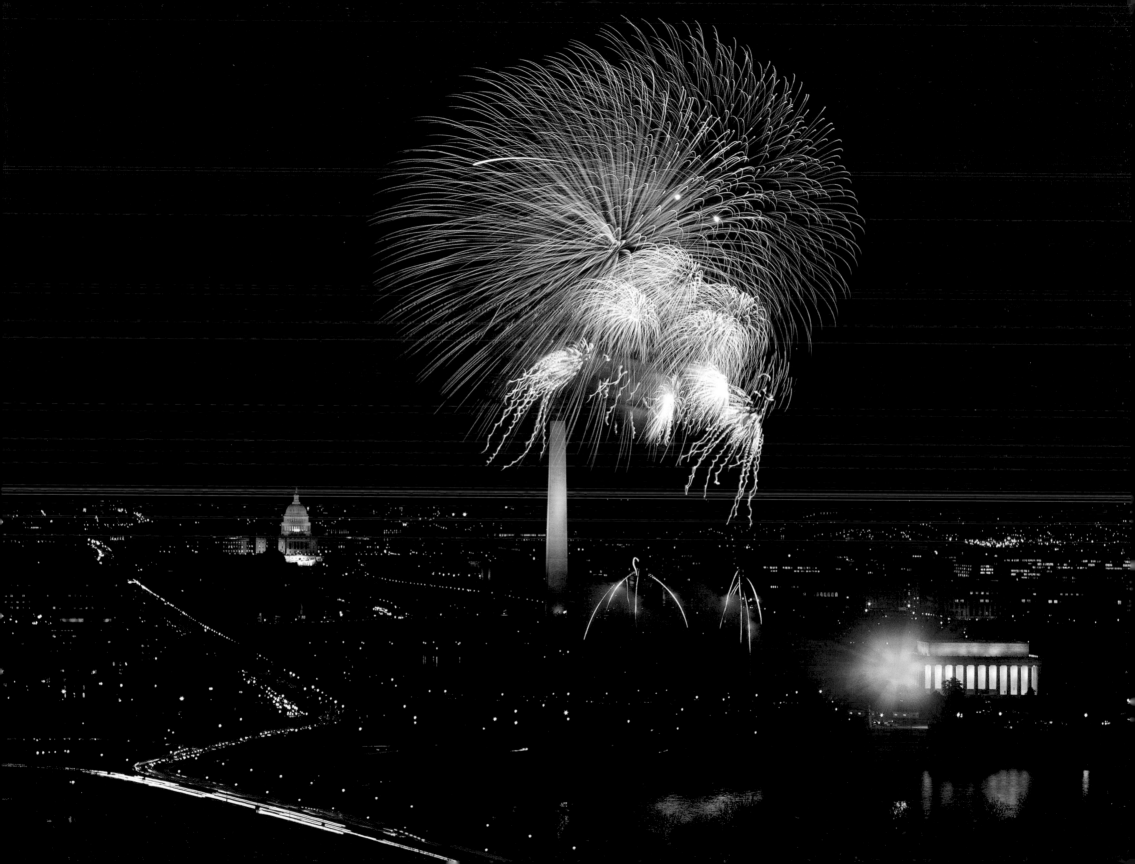

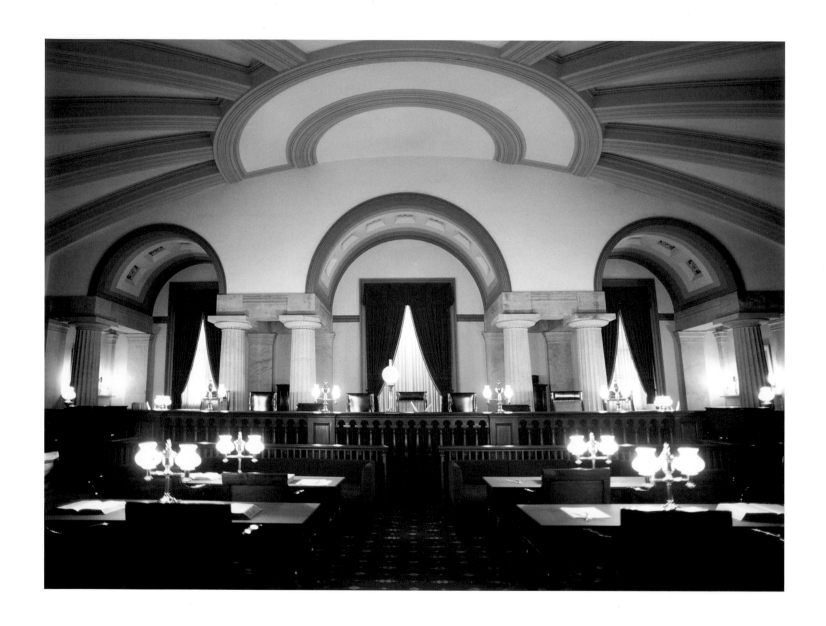

140 Old Supreme Court Chamber

TECHNICAL NOTES

The photographs in this book were taken with a variety of cameras—mostly 35mm, but also 2 1/4 and panoramic, using a wide range of lenses. When shooting interiors, and many exteriors as well, I often supplement the light that's available with flash.

Pictures were taken with both film and digital cameras. In either case, images were tweaked in Photoshop™ to adjust color and contrast and occasionally to eliminate or minimize distractions . . . but what you see here is essentially what I saw when I took each picture.

After graduating from Columbia College and Law School, Steve Gottlieb labored for ten years as a lawyer and senior corporate manager—primarily in Washington, D.C.—after which he turned his photography hobby into a second career.

Gottlieb's photographs of people, architecture and landscapes have appeared in thousands of advertisements, annual reports and editorial stories worldwide. He is the photographer/author/book designer of a number of books, including *American Icons* and *Abandoned America*. The latter was recognized by both *People* magazine and *USA Today* as "2002 Gift Book of the Year" and received "Best in Show" honors at the Chicago Book & Media Fair.

In 2005, Gottlieb founded—and teaches at—*Horizon Photography Workshops* in the historic, waterfront town of Chesapeake City, in northeast Maryland. *Horizon* was recognized by *American Photo* magazine as one of "12 Awesome Travel Workshops in the United States" (www.horizonworkshops.com). In addition, Gottlieb recently founded *VisionMining*, a company that uses photography as a teaching tool to help businesses and other organizations adapt to change and enhance innovation and teamwork (www.visionmining.biz). He can be reached at: info@horizonworkshops.com.

★　　★　　★

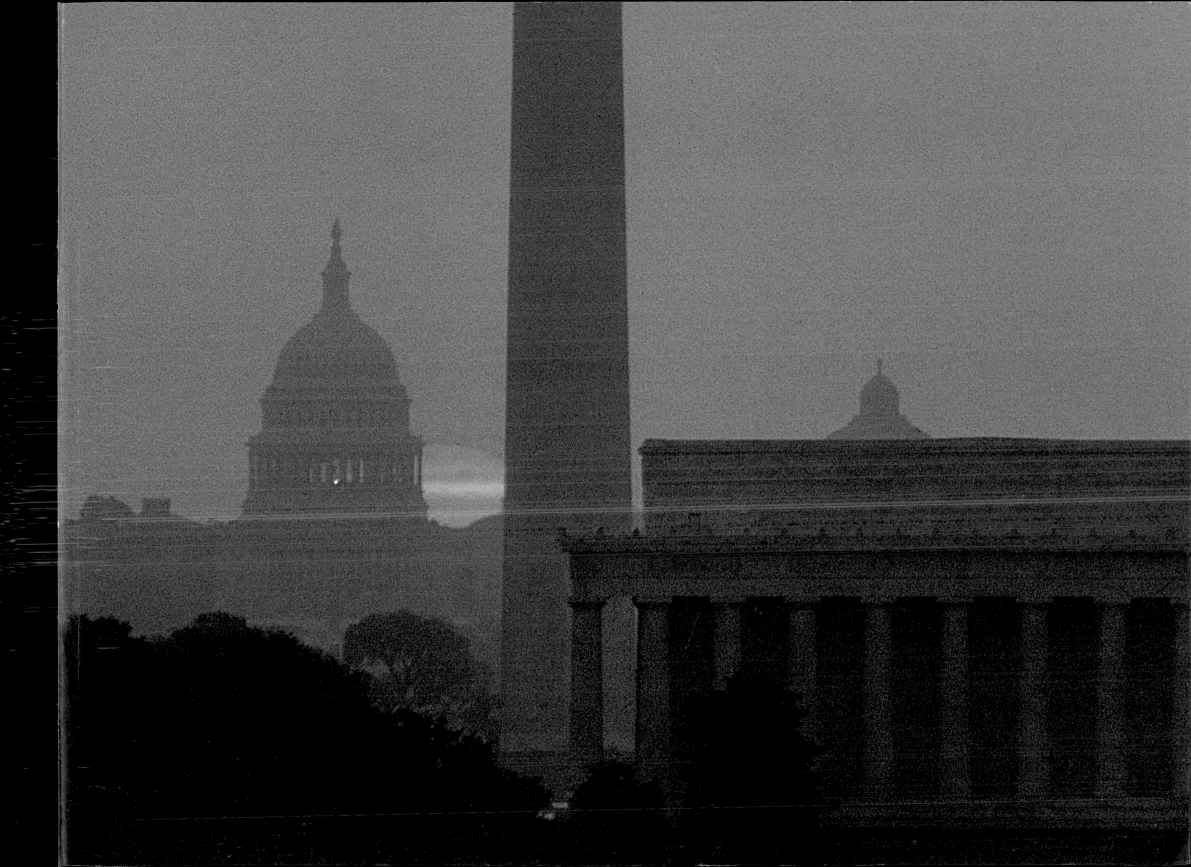